IMAGES
of America

Springfield's Sculptures, Monuments, and Plaques

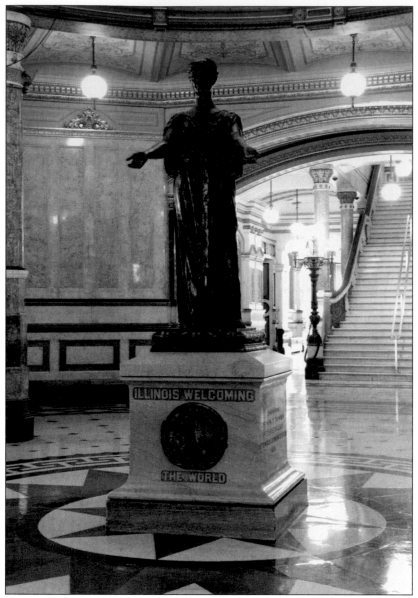

Illinois Welcoming the World greets visitors in the Illinois State Capitol rotunda. It is a bronze casting that duplicated the original plaster figure that stood in the reception room of the Illinois Building at the 1893 World's Columbian Exposition in Chicago. Created by Julia Bracken, assistant to Lorado Taft, the bronze was dedicated on May 16, 1895, "as a permanent memorial of the part which the women of Illinois took in the great Exposition." (Courtesy of Heather Hayes.)

On the cover: February 12, Abraham Lincoln's birthday, is a special day of celebration in Springfield. On February 12, 1935, the fledgling American Legion made its first annual pilgrimage to Lincoln's tomb. Among the dignitaries present for the ceremonies were Gov. Henry Horner; national commander of the legion Frank N. Helgrano Jr. of San Francisco; president of the legion auxiliary Mrs. A. C. Carlson of Willmer, Minnesota; and Springfield mayor John W. "Buddy" Kapp. (Courtesy of Sangamon Valley Collection, Lincoln Library.)

IMAGES
of America

SPRINGFIELD'S SCULPTURES, MONUMENTS, AND PLAQUES

Carl and Roberta Volkmann

ARCADIA
PUBLISHING

Published by Arcadia Publishing
Charleston SC, Chicago IL, Portsmouth NH, San Francisco CA

Printed in the United States of America

Library of Congress Catalog Card Number: 2007932712

For all general information contact Arcadia Publishing at:
Telephone 843-853-2070
Fax 843-853-0044
E-mail sales@arcadiapublishing.com
For customer service and orders:
Toll-Free 1-888-313-2665

Visit us on the Internet at www.arcadiapublishing.com

This book is dedicated to the countless amateur and professional historians, artists, and Lincoln buffs who have made and continue to make Springfield such an interesting and exciting place to live and work.

CONTENTS

ACKNOWLEDGMENTS

We could not have brought this book to publication without the assistance, support, and encouragement of numerous institutions, individuals, and friends. We are grateful to many local historians whose research and writing helped us bring our stories to life.

We wish to thank our editors at Arcadia Publishing, Ann Marie Lonsdale and Jeff Ruetsche, for guidance and encouragement. Thanks also to our Arcadia production editor Heather O'Neal.

We are especially grateful to the following fact checkers who caught some potentially embarrassing mistakes and typos: George Atkinson, Michael Dunbar, Linda Garvert, Keith Housewright, Mark Johnson, Curtis Mann, and Mark Sorensen.

We also want to thank Jo Ann Alessandrini, Jennie Battles, David Brady, Doug Carr, Joanie Caselton, Steve Dyer, Jim Edwards, Roberta Fairburn, Bill Furry, Jeff Garland, Amanda Gleason, Pat Glenn, Jim and Jan Grimes, Susan Haake, Kathryn Harris, Jim Hawker, Heather Hayes, Ross Horne, Nancy Huntley, LuAnn Johnson, Elena Kezelis, Mike and Kathy Klemens, Amanda (Londrigan) Staab, Rabbi Barry Marks, Linda Medlock, Jerry Melton, Mary Michals, Ken Mitchell, Thomas O'Brien, John Paul, Taylor Pensoneau, John Popolis, Lindsey (Price) Harney, Paul Riemer, Kathie Sass, Tom Skelly, Chris Smith, John Standish, Richard Stone, Marianne Stremsterfer, Talon Thornton, Nancy Travis, Mark Whitlock, Graham Woerner, Harold and Jackie Wright, Judy Wright, and Nan Wynn.

Unless otherwise noted, all images are from our collection.

INTRODUCTION

Springfield, Illinois, is a city of contrasts. Nowhere is that more evident than in its history. Abraham Lincoln, "the Great Emancipator," spent 24 years of his life in the city. Yet in 1908, race riots killed seven people, ruined 40 homes, and destroyed 24 businesses within 48 hours. Susan Lawrence Dana, a local socialite, provided an open check book to Frank Lloyd Wright in 1902–1904 to design and build an opulent home for entertaining. Just a few blocks south of Dana's home was the Home for the Friendless. Founded in 1863, the orphanage cared for thousands of homeless and needy children. These contrasts and much more are documented in the city's plaques and artworks.

This book uses contrasting elements to tell Springfield's diverse story. The collection reveals well-known facts and lesser-known details, notable events and mundane incidents, famous historic figures and Springfield's ordinary citizens. The depicted works themselves encompass styles ranging from classical monuments found in Oak Ridge Cemetery to contemporary sculptures installed on university campuses. They have been created by world-renowned sculptors as well as emerging artists.

The vision of the authors is that this collection will serve three functions: a record of history, a guide for exploring Springfield, and a springboard for future research. Because Lincoln dominates the Springfield historic scene, many of the images relate to our 16th president. However, a wide range of other themes and individuals are also included. For example, Oak Ridge Cemetery, best known as Lincoln's final resting place, also has monuments honoring soldiers from the Revolutionary War, the Civil War, World War II, the Vietnam War, and the Korean War. Springfield-native Vachel Lindsay, famed poet and singing troubadour of the early 20th century, is honored with a gravestone in Oak Ridge Cemetery and a plaque on his home. A plaque on the Elijah Iles House, Springfield's oldest house, memorializes Iles, who was one of the city's earliest settlers. Relatively new monuments to those who died on September 11, 2001, stand on the capitol lawn and the Capital Area Career Center.

To aid the reader who chooses to seek out a statue, monument, or plaque, most captions describe the location of the image they accompany. *Springfield's Sculptures, Monuments, and Plaques* is written so that the armchair historian and the city explorer can discover the rich and varied record of Springfield through the eyes of those who have chosen to preserve history through artworks and plaques.

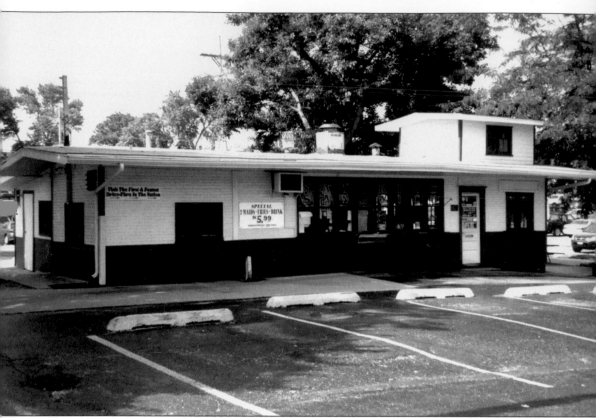

Just to the left of the entry door of the Maid-Rite restaurant at Jefferson and Pasfield Streets is a plaque that reads: "This property has been placed on the National Register of Historic Places by the U.S. Department of the Interior Circa 1924." Opened in August 1924, the diner still provides in the original building drive-thru service (an innovation in 1924), trademark Maid-Rite sandwiches of loose ground beef with spices, and homemade root beer. In 1926, the Springfield Maid-Rite evolved into one of the first restaurants in the country to become a franchise. The franchise currently operates more than 70 restaurants nationwide. Except for the addition of a larger dining room space, the building, menu, and service are much the same as they were in 1924 in the shadow of the Illinois State Capitol.

One

WHERE GOVERNMENT LEADS
ILLINOIS STATE BUILDINGS

Springfield is the third Illinois city to serve as the state capital. When Illinois was admitted to the Union in 1818, Kaskakia became the first capital. In 1820, the government was moved to Vandalia. Through the efforts of a group of nine legislators from Sangamon County, led by the young Abraham Lincoln, the 1836–1837 Illinois General Assembly named Springfield the third capital city. The state government began functioning in Springfield in 1839. From 1840 to 1876, the seat of government was the Greek Revival building at the center of downtown that is now known as the Old State Capitol.

On February 24, 1867, the 25th Illinois General Assembly authorized the construction of the present capitol building. Twenty-one years later, in 1888, the structure was completed. It housed the judicial, executive, and legislative branches as well as government departments, regulatory boards, military leaders, three museums, several libraries, and the state's archives. The first statues that adorned the building were the large memorial to Pierre Menard on the Second Street lawn and sculptor Leonard Volk's Abraham Lincoln and Stephen A. Douglas statues in the east hall of the building.

Over the years, many more statues and plaques were placed on the lawn. Furthermore, several other monuments and sculptures flank the sidewalk on the east side of the statehouse. Inside the capitol, eight life-sized statues of Illinois legislators stand in niches on the second-floor rotunda, and eight figures of early Illinois leaders look down from corbels above the fourth level. Agencies have been moved to other buildings, and commemorative pieces have been incorporated into those structures. Most notable is the Department of Revenue's Willard Ice Building. Built in the 1980s, the Willard Ice Building is a showcase of contemporary Illinois art purchased through the Art in Architecture (A-i-A) Program of the Capital Development Board. This program specifies that one half of 1 percent of the amount appropriated for the construction of state-funded buildings be allocated for original art. The statues, monuments, and plaques on state property not only reflect the history of Illinois, but also reveal the history of public art and commemorative recognition.

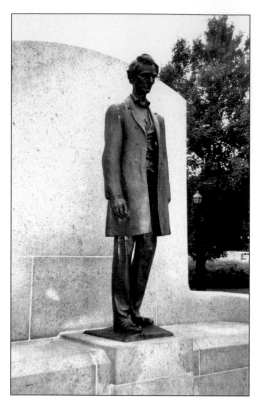

The statues of Abraham Lincoln and Stephen A. Douglas on the state capitol grounds were both funded by the same 1913 appropriation and dedicated on October 5, 1918, the centennial of the first meeting of the Illinois General Assembly. Called *The Lincoln of the Farewell Address,* the Lincoln bronze (left) is said to depict the president-elect making his Springfield farewell address. That speech is engraved on the granite slab behind him. Sculpted by Andrew O'Connor, the 10-foot Lincoln faces Second Street and has become one of the most photographed sites in Springfield. The statue of Douglas (below), created by Gilbert Riswold, stands between Lincoln and the east steps of the capitol. Originally the Douglas bronze was facing Second Street north of Lincoln, but in 1935, it was moved to its present site because of popular sentiment to have Douglas closer to the capitol.

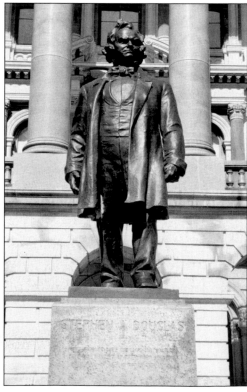

The statues of Richard Yates (right) and John M. Palmer (below) were dedicated jointly on October 16, 1923. The political career of Yates included terms as an Illinois legislator, U.S. senator, and Illinois governor during the Civil War (1861–1865). As governor, Yates was extremely effective in raising troops for the Union and was known as the "wounded soldier's friend." The Palmer statue is north of Albin Polasek's Yates bronze. An outspoken critic of slavery who helped create the Republican Party, Palmer served as a general in the Civil War. He was elected governor of Illinois in 1868, and in 1891, the Illinois General Assembly appointed him to the United States Senate. His nine-foot-tall statue on the southeast lawn of the state capitol is by Leonard Crunelle. (Right, courtesy of Sangamon Valley Collection, Lincoln Library.)

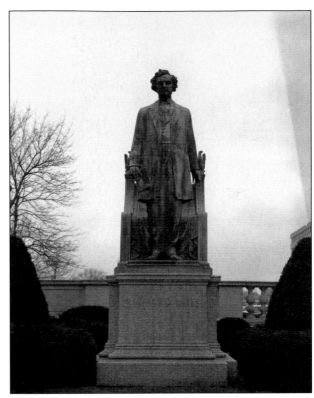

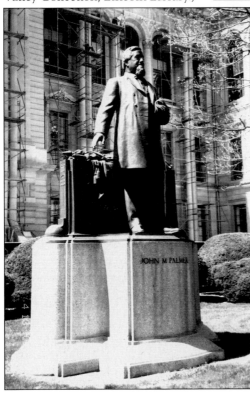

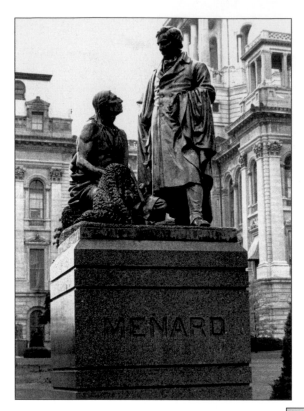

The eight-foot statue of Pierre Menard, the first lieutenant governor of Illinois, rests on a 10-foot granite pedestal on the south capitol lawn facing Second Street. The Native American figure symbolizes Menard's success as a fur trader. Originally placed on the northeast lawn in 1888, the bronze was moved to its present location in 1918. It was created by John Mahoney of Indianapolis. (Courtesy of Sangamon Valley Collection, Lincoln Library.)

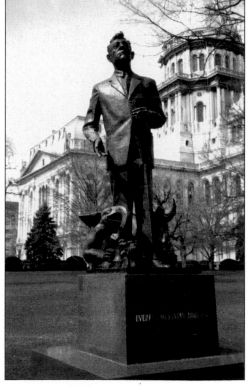

On the southwest corner of the state capitol lawn, sculptor Carl Tolpo depicts Everett McKinley Dirksen with humor. At the feet of a rumpled Dirksen are a donkey, an elephant, and an oil can symbolizing his oratorical and persuasive skills. Also joining the animals is Dirksen's favorite flower, the marigold. This light-hearted tribute to Dirksen, who served as Illinois congressman and U.S. senator for 34 years, was dedicated in 1976.

Facing Second Street on the north end of the state capitol lawn is a memorial to coal miners who have been killed in Illinois mines. Because of the strong advocacy of miner, poet, and artist Vachel Davis, the legislature appropriated $15,000 for the project. Davis then worked with Tinley Park sculptor John Szaton to transform a Davis painting into the seven-foot bronze statue. Speeches at the dedication ceremony on October 16, 1964, were given by Gov. Otto Kerner and Paul Powell, former speaker of the Illinois House of Representatives. Michael F. Widman Jr. represented the United Mine Workers of America in the absence of the union's president John L. Lewis, who was too ill to attend. A plaque identifying the sculptor was added at the request of Tinley Park citizens in 1981. (Below, courtesy of Sangamon Valley Collection, Lincoln Library.)

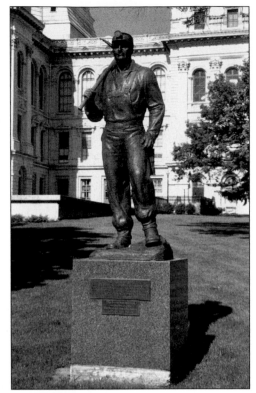

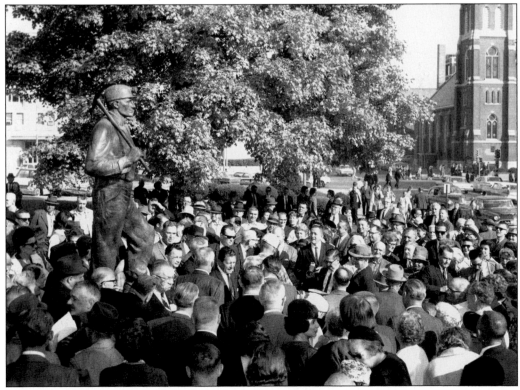

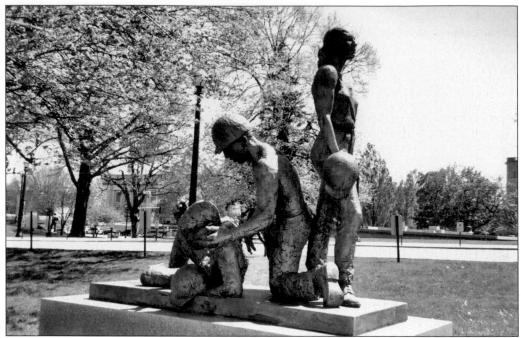

The Illinois Workers Memorial, *Mourn for the Dead, Fight for the Living* by Peter Fagan, is on the north lawn of the capitol. The nine-foot, 3,500-pound bronze sculpture depicts an injured worker with his companions. Commissioned and funded by members of the Illinois American Federation of Labor and Congress of Industrial Organizations (AFL-CIO) and the Chicago Federation of Labor, the work commemorates the Occupational Safety and Health Administration Act. The dedication was on April 28, 1992, Workers Memorial Day.

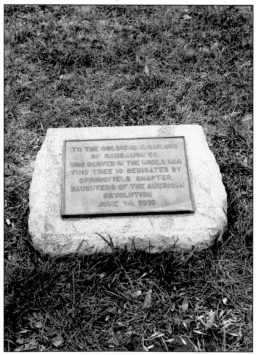

A large elm tree stands between the sidewalks leading to the east doors of the capitol. A plaque near each sidewalk explains that the tree was planted by the Daughters of the American Revolution (DAR) in 1919 to honor the soldiers and sailors of Sangamon County who served in World War I. The dedication was on June 14, 1919, with Sgt. Earl Searcy accepting the memorial from Mrs. James King. (Courtesy of Sangamon Valley Collection, Lincoln Library.)

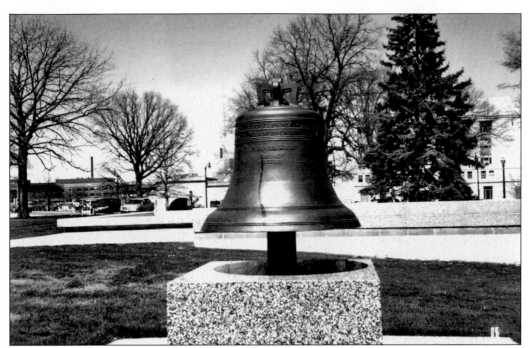

The bronze reproduction of the original Liberty Bell in Philadelphia is on the state capitol grounds near the corner of Second and Monroe Streets. Originally used to promote the sale of U.S. savings bonds in 1950, the bell was stored at the Illinois State Fairgrounds until 1976 when it toured the state as a part of the nation's bicentennial celebration. It was placed in its present location in 1977.

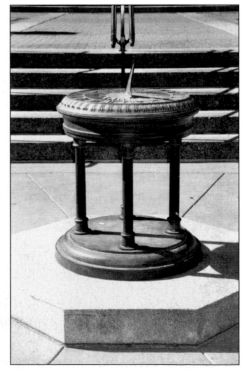

A bronze sundial stands near the north entrance of the capitol. The Daughters of Union Veterans of the Civil War donated the piece and dedicated it to the Grand Army of the Republic (GAR) in an elaborate ceremony on September 8, 1940. In addition to several distinguished speakers, the more than 500 guests heard the U.S. Marine Band.

15

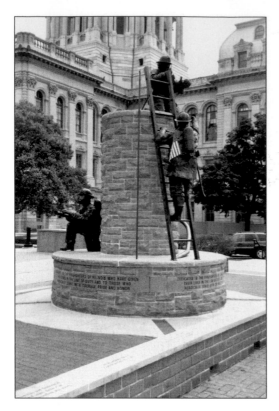

Neil Brodin, creator of the Illinois Firefighter Memorial, is a former Minneapolis policeman whose company's law enforcement memorials are found throughout the country. Standing between the William Stratton Building and the capitol, the Illinois memorial has four life-size bronze firefighters in action on a 14-foot cairn. This memorial was dedicated on May 13, 1999.

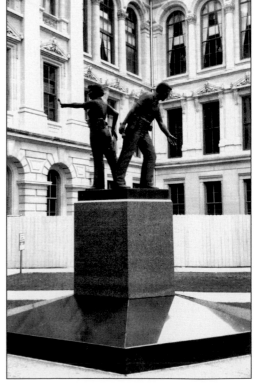

Found near the Illinois Firefighter Memorial is the Illinois Police Officers Memorial, which was dedicated on October 29, 1990. Each succeeding May a ceremony is held to honor the officers killed in the line of duty that year and to add their names to the original 643 names on the piece. Keith Knoblock, an instructor at Illinois State University, created the life-sized bronze figures that are surrounded by polished black granite slates.

16

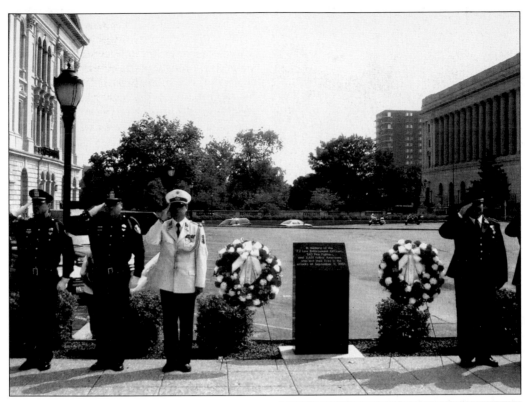

The black granite *Ride to Remember 9-11* memorial, found between the police and firefighter memorials on the capitol grounds, was dedicated in September 2005 by the Blue Knights Law Enforcement Club of Illinois to remember the victims of the 9/11 terrorist attacks. Shown (above) at the dedication on the left are members of the Springfield Police Department Honor Guard and a command officer from Vienna, Austria. Members of the Springfield Fire Department Honor Guard are on the right. Etched pictures of the World Trade Center, the Pentagon, the Pennsylvania crash site, and firefighters raising the flag at Ground Zero decorate the four sides. A memorial service is held at the monument annually on the second Sunday in September. (Above, courtesy of Ross Horne.)

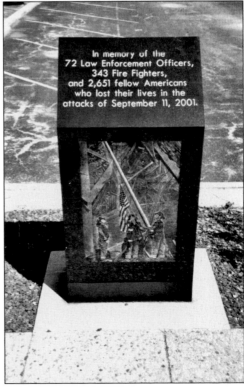

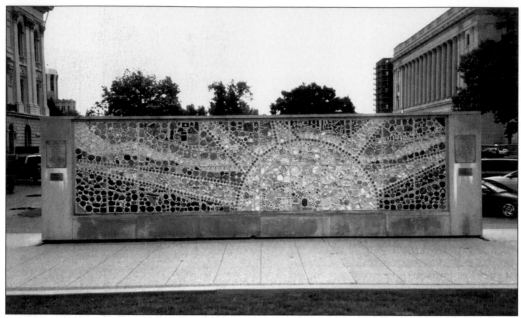

After students with disabilities who were participants in seven Very Special Arts Festivals around Illinois created 1,400 ceramic pieces, art teachers Pat Imming of Highland and Pat Winkle of Edwardsville incorporated them into this mosaic mural, which stands on the sidewalk adjacent to the Illinois State Museum. The construction was funded by the Regional School Superintendents and the Graham Foundation. It was dedicated in May 1985.

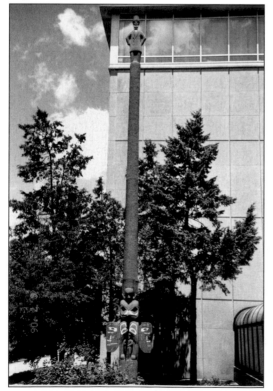

Proud Raven at the entrance of the Illinois State Museum is a fiberglass replica of the original totem created by natives from Tongass Island, Alaska, in about 1883. According to legend, a chief commissioned a totem pole to commemorate a relative who had been the first of his tribe to see a white man. A photograph of Abraham Lincoln was the model for the man at the top of the pole.

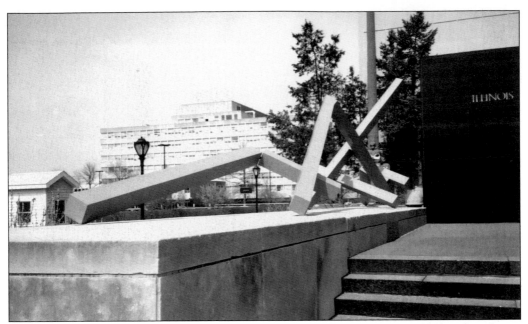

Since 1973, *Illinois Landscape #3 (Shawneetown to Chicago)* has rested on a wall at the Illinois State Museum entrance. In tribute to Illinois's agricultural industry, the fabricated aluminum structure is painted Rust-Oleum No. 7448, formerly Caterpillar Tractor Company yellow. Works by the creator, Chicago artist John Henry, can be found in many private and public collections including the Smithsonian Institution.

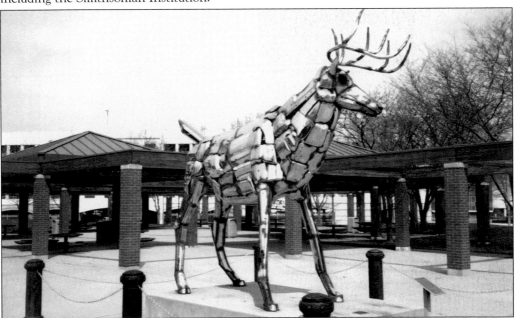

Like his other animal creations, John Kearney's *White-tailed Deer* is constructed with welded chrome car bumpers. Illinois school children elected the white-tailed deer the state animal in 1980. Wags call this a monument to all Illinois deer that have been killed by car bumpers. Standing 13 feet tall and weighing 1,500 pounds, the deer has been amusing children and adults at the capitol complex visitors' center since 1994.

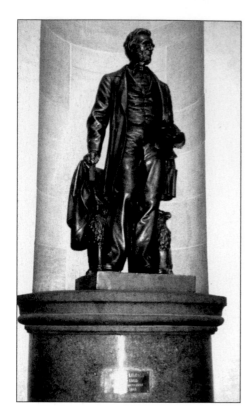

Reflecting their famous debates, Abraham Lincoln (left) and Stephen A. Douglas (below) face each other from their niches on the second-floor rotunda of the Illinois State Capitol. Both statues were completed in 1876 by Chicago sculptor Leonard Volk, famous for the life masks and hand casts he created when Lincoln posed for him in 1860. Each statue stood on a wooden box in the east hall of the current second floor from the time they arrived at the capitol on January 7, 1877, until they were moved to their pedestals in 1894. They are executed in plaster with a coating resembling bronze.

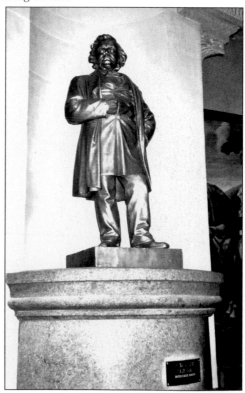

The niche statue of Chicagoan David E. Shanahan, a member of the Illinois House of Representatives for 42 years (1894–1936), was created by Frederick C. Hibbard in 1939. Shanahan served as speaker of the house six times during his tenure. His 1936 death while still in office opened the door for Richard J. Daley to be elected to the Illinois House of Representatives for the first time.

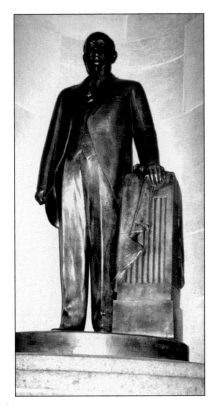

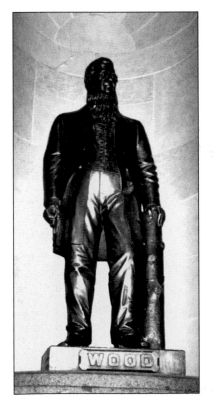

The statue of John Wood that stands in the second-floor niche was a gift from the citizens of Quincy. Wood was mayor of that city three times and represented that community as a state senator in 1850. He was elected lieutenant governor in 1856. On the death of Gov. William H. Bissell in 1860, he became the 12th governor of Illinois. The statue is by Cornelius Volk, older brother of Leonard.

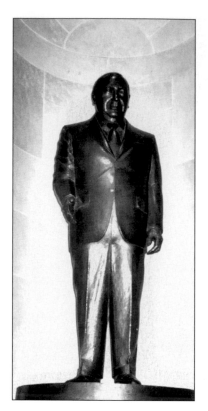

Through an invitational competition, the State of Illinois commissioned Peter Fagan in 1981 to create the *Portrait of Richard J. Daley* found in a second-floor niche. The mayor of Chicago for over 21 years, Daley also served in the Illinois General Assembly for 10 years and was the state revenue director. The *Illinois Workers Memorial* on the capitol lawn was also sculpted by Fagan, a University of Illinois at Urbana-Champaign faculty member.

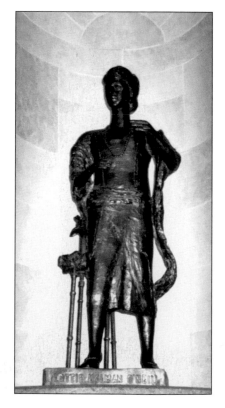

The only woman statue in a niche is DuPage County's Lottie Holman O'Neill, who served 38 years in the general assembly. A pioneer in women's politics, she was the first woman to serve in both the Illinois House of Representatives and Senate. A comparison of the O'Neill piece with the Abraham Lincoln statue outside Springfield's Lincoln Library reveals the versatility of the sculptor, Abbott Pattison. The O'Neill sculpture was dedicated in 1976.

Richard J. Barr, former mayor of Joliet, also holds a place of honor in a second-floor niche. Barr was state senator from the 41st District for 48 years (1903–1951). His statue was sculpted in 1953 by Trygve A. Rovelstad, a student of Lorado Taft. Born in Elgin, Rovelstad was a medalist sculptor who designed medals for the U.S. military as well as civilian organizations.

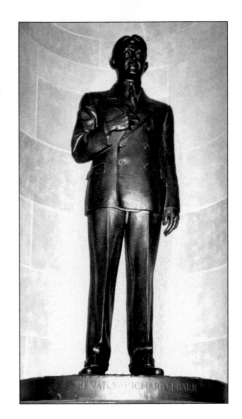

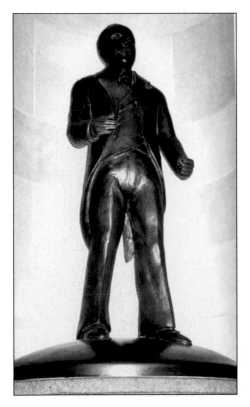

In 1924, Chicago attorney Adelbert H. Roberts was the first African American to be elected to the Illinois Senate. Before his death in 1937, he was elected twice to the senate and three times to the Illinois House of Representatives. In 1927, Roberts was the first African American to chair a committee in the Illinois legislature. His image, sculpted by Richard Hunt, was added in 1984.

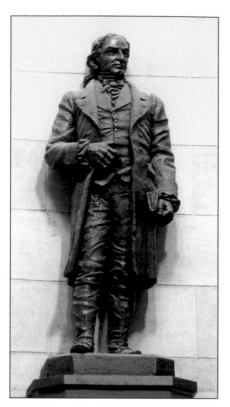

Eight 10-foot statues of early Illinois leaders stand on corbels above the fourth level of the capitol building. They include the first three governors of the state, a president of the United States, and four Illinois representatives to the U.S. Congress. The artistic quality of the statues was highly controversial. Recent investigations conclude that they are made of hollow bronze-coated pot metal with no artists' signatures. At the end of the contentious and prolonged process of selecting the "Honored Eight," Shadrach Bond (left) and Edward Coles (below) were among the chosen. As first governor, Bond initiated a system of privately operated toll roads and bridges to develop the new state's nonexistent transportation infrastructure. Leadership in antislavery initiatives is the hallmark of the tenure of Coles, the second governor of Illinois. (Courtesy of Heather Hayes.)

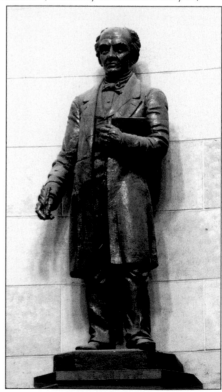

One corbel statue is of Ninian Edwards, the third governor of Illinois. Edwards served as governor of the Territory of Illinois from 1809 to 1818. When Illinois was admitted to the Union, Edwards was elected to the U.S. Senate, serving from 1818 to 1824. After returning to his law practice, he was elected governor of Illinois in 1826. (Courtesy of Heather Hayes.)

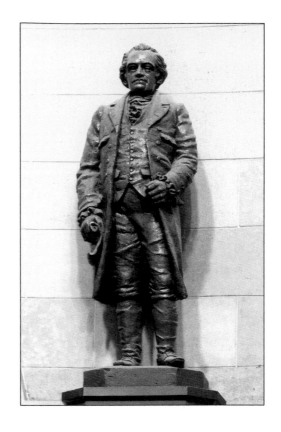

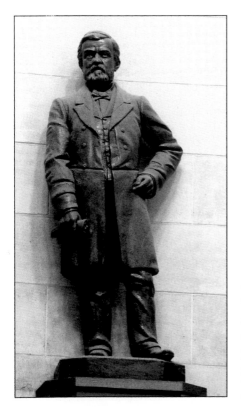

The most famous of the corbel Honored Eight is Ulysses S. Grant, 18th president of the United States. A West Point graduate, Grant was working at his father's leather store in Galena at the outbreak of the Civil War. After his appointment to the army, he quickly rose to become one of the war's most honored heroes and eventually president. (Courtesy of Heather Hayes.)

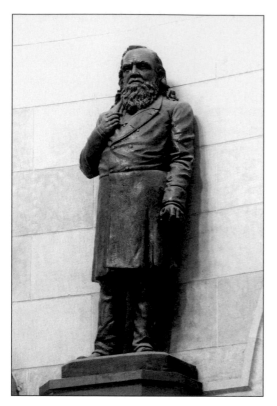

The record of public service leadership by Sidney Breese is long and varied. In addition to serving in the U.S. Senate, this member of the Honored Eight was judge and chief justice of the Illinois Supreme Court and speaker of the Illinois House of Representatives. He held several commissions in the militia and served as lieutenant colonel of volunteers in the Black Hawk War. (Courtesy of Heather Hayes.)

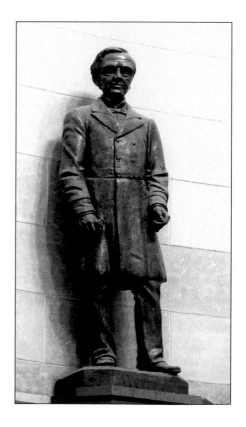

The corbel statue of Lyman Trumbull honors his long service as U.S. senator. Trumbull represented Illinois in the senate from 1855 to 1873. During his tenure, he was chairman of the Committee on the Judiciary. Before going to Washington, Trumbull served as a member of the Illinois House of Representatives, secretary of state, and a justice of the U.S. Supreme Court. (Courtesy of Heather Hayes.)

John A. Logan is remembered with a corbel statue because of his extensive military and political career. The Murphysboro native served in both the Mexican and Civil Wars as well as in both houses of the U.S. Congress. Logan inaugurated the Memorial Day holiday in May 1868. (Courtesy of Heather Hayes.)

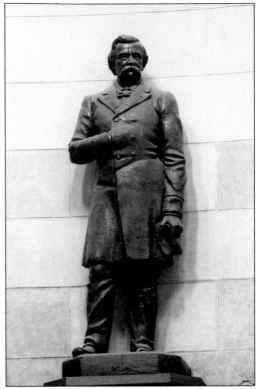

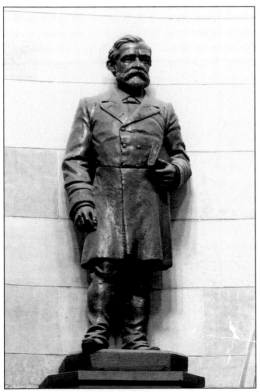

Waterloo-native William Ralls Morrison, one of the Honored Eight, represented Illinois in the U.S. House of Representatives from 1863 to 1865 and from 1873 to 1887. When he completed his congressional service, Morrison was appointed by Presidents Grover Cleveland and Benjamin Harrison to the Interstate Commerce Commission from 1887 to 1897. He served as chair of the commission the last five years of his appointment. (Courtesy of Heather Hayes.)

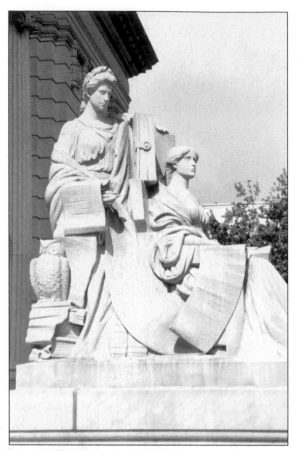

Law and Knowledge (left) and *Justice and Power* (below) by famed sculptor Charles J. Mulligan guard the north doors of the Illinois Supreme Court building on Capitol Avenue. Mulligan studied under Lorado Taft at the Art Institute of Chicago and Alexander Faleuiere in Paris, France. He succeeded Taft as head of the department of sculpture at the Art Institute. Other famous works by Mulligan include his *Lincoln as a Railsplitter* in Chicago's Garfield Park and *Lincoln the Orator* in Rosamond Grove Cemetery in Rosamond. The Illinois Supreme Court statues were completed sometime between 1908 and 1910.

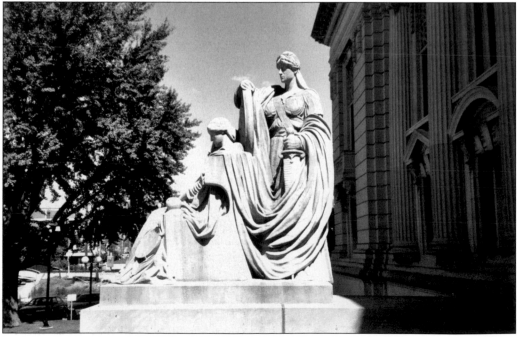

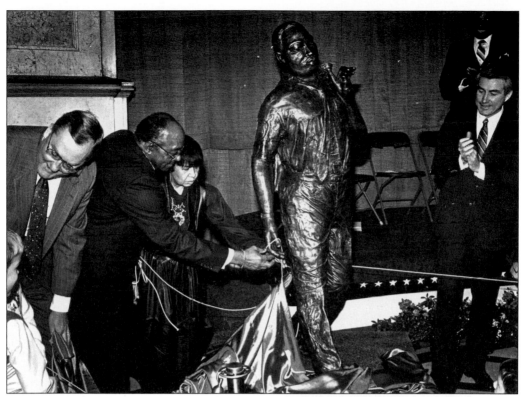

Miles to Go before I Sleep, the Martin Luther King Jr. statue by Geraldine McCullough, stands at "Freedom Corner" on the southwest corner of the Illinois State Library, facing the statehouse and the Abraham Lincoln statue. Artist McCullough is pictured (above, third from left) unveiling the statue in the capitol rotunda on January 14, 1988, with then governor James Thompson in the foreground. In 1989, the statue was placed on a site seen by some as obscure behind the state archives. Responding to protests, the Legislative Space Needs Commission moved the statue to its present location for rededication on September 18, 1993. The six-foot statue is cast in bronze with eyes of polished agate inlaid on the bronze. It stands on a four-foot granite base. (Above, courtesy of Sangamon Valley Collection, Lincoln Library.)

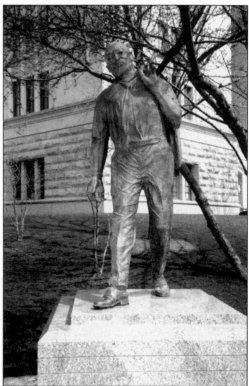

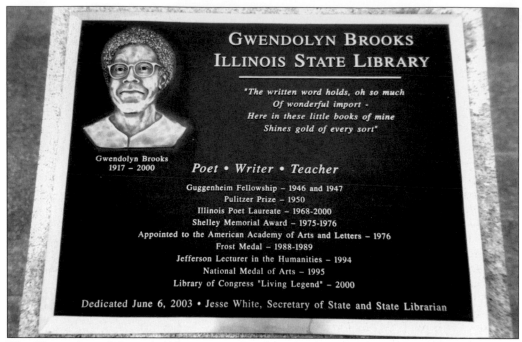

GWENDOLYN BROOKS
ILLINOIS STATE LIBRARY

"The written word holds, oh so much
Of wonderful import -
Here in these little books of mine
Shines gold of every sort"

Gwendolyn Brooks
1917 – 2000

Poet • Writer • Teacher

Guggenheim Fellowship – 1946 and 1947
Pulitzer Prize – 1950
Illinois Poet Laureate – 1968-2000
Shelley Memorial Award – 1975-1976
Appointed to the American Academy of Arts and Letters – 1976
Frost Medal – 1988-1989
Jefferson Lecturer in the Humanities – 1994
National Medal of Arts – 1995
Library of Congress "Living Legend" – 2000

Dedicated June 6, 2003 • Jesse White, Secretary of State and State Librarian

The Illinois State Library building at 300 South Second Street was renamed the Gwendolyn Brooks Illinois State Library in 2003. Gwendolyn Brooks was the Illinois poet laureate from 1968 to 2000. She was the first African American to win a Pulitzer Prize. She is one of the 35 Illinois authors whose names are etched on the exterior fourth-floor frieze of the building.

The June 17, 1948, unveiling of the Spanish-American War Memorial was the highlight of a four-day encampment of the United Spanish War Veterans. The monument consists of a nine-foot bronze "Liberty" figure flanked by a sailor and an infantryman. The three stand on an eight-and-a-half-foot-high granite base. Created by Fredrick C. Hibbard, the memorial is located on the Monroe Street side of the Illinois State Armory.

Two bas-relief sculptures by world-renowned mid-20th century artists are located in the Michael Howlett Building. Dedicated in 1930, a tribute to the mothers of World War I Illinois soldiers (right) is on the northeast end of the "Hall of Flags." The sculptor was Leon Hermant, a prolific French-born artist who made his home in Chicago. Hermant's figures and architectural sculptures are found throughout the Chicago area. In the southwest hall of the building is a monument by Nellie Walker dedicated in 1914 to the soldiers of the War of 1812 (below). Walker is considered one of America's foremost women sculptors. She was a colleague of Lorado Taft at the Art Institute of Chicago. Her many monumental works are found throughout the Midwest including the sculptured panels *Health* and *Happiness* flanking the doors of Springfield's water plant.

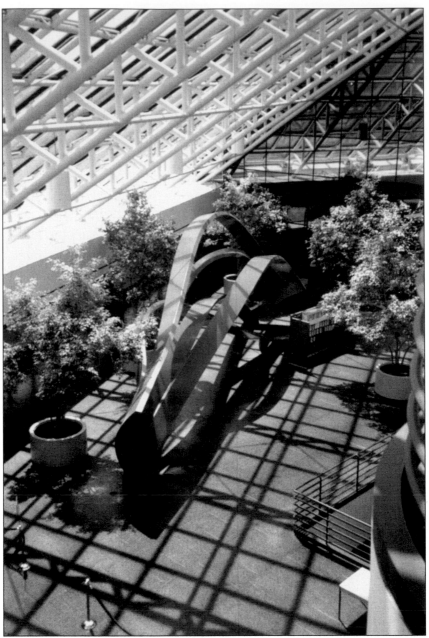

In 1986, through the A-i-A Program of the Capital Development Board, artworks by professional Illinois artists were selected by a competitive process to be on permanent display inside and outside the central office of the Illinois Department of Revenue, the Willard Ice Building. The ice complex at 101 West Jefferson Street houses the largest collection of contemporary art for a public building in downstate Illinois: seven sculptures, one mobile, one three-dimensional wall piece, and 21 paintings. The central sculpture in the collection is *Delphin* by Bruce White. The two-ton structure was incorporated into the structural design of the building. To create the illusion of a graceful delicately balanced ribbonlike form in the atrium of the lobby, the painted aluminum sculpture was welded into the superstructure of the building's framework. The building was then constructed around the artwork.

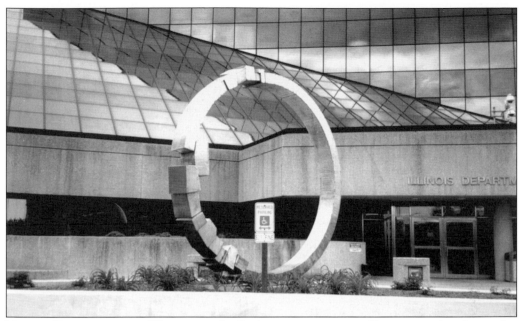

Virginio Ferrari, creator of *Formation of a Circle*, is an internationally recognized sculptor who resides in both Chicago and Verona, Italy. His work has been described as lyrical, and he holds many awards for his vitalization and humanization of urban spaces. The monumental stainless steel structure outside the Willard Ice Building measures 13 and one half feet in diameter.

The work of Christiane Martens represents a synthesis of art, design, and engineering. Her *Energy 1 for Helmut* found on Jefferson Street outside the Willard Ice Building uses color on steel to exploit the dynamic character of the rolled planes and kinetic forms. She says, "[in] outdoor settings . . . variations in light and atmospheric conditions will produce mutations of color . . . [which] add to the art work's interest and vitality."

Pieces such as a woman with her hat and a birdbath created from ceramics, bronze, and fiberglass rest within green plantings in the Keith Knoblock sculpture *Moon Pool-Janus View* in the center of the Willard Ice Building. The result is the illusion of a peaceful garden area in the midst of a busy office. The Illinois Police Officers Memorial on the capitol lawn is another work by sculptor Knoblock.

Elements of sculptor Joe Agati's interest in furniture design can be detected in this untitled wooden structure. The eight-by-eight-by-eight-foot sculpture is a simple and formal gridlike piece. In contrast to the stark white Willard Ice Building and green plantings, it exudes an ominous and monolithic presence. The sculpture symbolizes the serious business of the office and complements the more playful artworks that surround it.

In *Pragnanz Series,* sculptor William Carlson cut, polished, and laminated glass on granite to create a structure that repeats the color scheme and patterns of the foliage, overhead trusses, and windows of the interior of the Willard Ice Building. Head of the crafts and sculpture programs at the University of Illinois at Urbana-Champaign, Carlson is considered one of the most important figures in the studio glass movement.

When Terrence Karpowicz served as a millwright's apprentice, he discovered the beauty and craftsmanship of water and windmill construction. He applies the traditional techniques of joinery and the interactions of the elements and gravity in his works such as the kinetic sculpture *Alpha Centurian.* Since the center of the 12-foot wooden piece can be rotated, the work provides a bit of whimsy in the office setting.

A multicolored stained-glass mobile sculpture hangs above the work space and greenery in the Willard Ice Building. Springfield artist Ralls Melotte is an illustrator and architect as well as a stained-glass sculptor. The piece, titled *Flight of the Rainbow Goblins*, adds a touch of color to the atrium as it catches the sunlight.

A-i-A commissioned *Watershed* in the Department of Natural Resources building is Chicago-artist Mike Baur's image of the water towers that once stood beside railroad tracks to provide water to locomotives. Baur designed the 60-foot-tall piece in 2001 with concrete, steel, oak, and water, but as of 2007 a water pump has not yet been installed. Baur's other large public sculptures are found throughout the United States and in Barcelona, Spain.

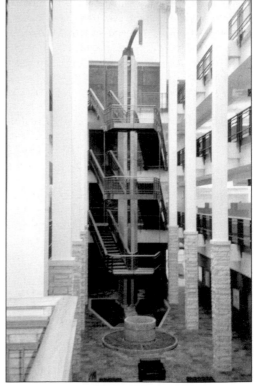

Two

WHERE LINCOLN WALKED
LINCOLN'S NEIGHBORHOOD

Abraham Lincoln, the 16th president, arrived in Springfield in 1837 as a new lawyer and left in 1861 as the president-elect. The community was the background for his personal and political growth. He married, established a home, had children, and buried a child in Springfield. He practiced law and served in the Illinois legislature. When he left Springfield for Washington, he said to the approximately 150 friends who came to wish him well, "To this place, and the kindness of these people, I owe everything. . . . I now leave, not knowing when or whether ever, I may return. . . . I bid you an affectionate farewell." Lincoln returned to Springfield in death and was buried in Oak Ridge Cemetery.

Lincoln continues to be a towering presence in Springfield. The attraction of his lore and legacy to people from all over the world makes tourism a major industry for the community. The National Park Service maintains his home and the neighborhood surrounding it. The Illinois Historic Preservation Agency oversees sites important to Lincoln's career such as his law office and the Old State Capitol. Since its opening in 2005, the Abraham Lincoln Presidential Library and Museum has attracted thousands of visitors. The 200,000-square-foot complex includes an archive, library, and museum. Telling the Lincoln story with high tech interactive experiences, galleries, and theaters, the museum has become the most visited presidential museum in the country.

Lincoln's story has been commemorated with plaques and statues in his neighborhood for many years. One can still read his farewell address to Springfield on a plaque on the Old State Capitol Plaza erected in 1915 by the Springfield Chapter of the Illinois DAR. Other organizations have continued the tradition, and since 2005, large informational signs have been placed throughout the downtown area by the Looking for Lincoln Heritage Coalition. For anyone seeking to understand the Great Emancipator, the plaques and statues provide a sense of reality and insights into the life of Springfield's favorite son.

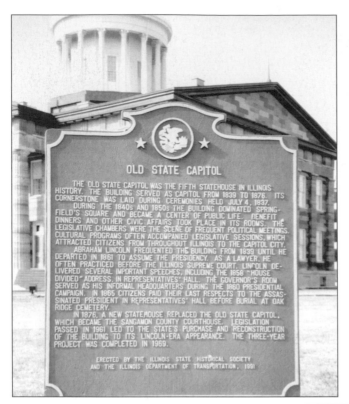

This plaque stands on the lawn of the Old State Capitol, the focal point of the Old State Capitol Plaza. It was the seat of state government from 1839 to 1876. The building was dismantled in the 1960s and rebuilt using the original stone exterior. The interior was reconstructed to authentically recreate the Illinois statehouse of Lincoln's day (1840–1860). Rededicated on December 3, 1968, the Old State Capitol is open for visitors.

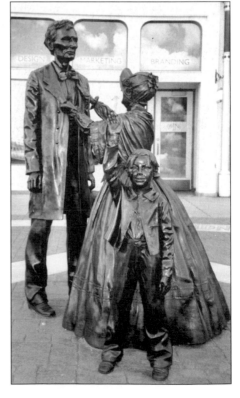

The life-size Abraham Lincoln family standing on the Old State Capitol Plaza depicts Lincoln as he walks to the capitol to give the speech tucked in his hatband. Mary adjusts her husband's lapel, and Willie waves to Robert who is several feet away. In *Springfield's Lincoln*, sculptor Larry Anderson intended to create a single moment in Lincoln's life that symbolizes the influence of his Springfield domestic life on his political career.

Eighteen plaques are found on two walls of the kiosk leading to the underground parking garage on the south Old State Capitol Plaza. The plaques include six that honor individual past commanders in chief of the GAR and two erected by the Springfield chapter of the DAR, which mark Lincoln's path as he rode the historic eighth circuit. The first DAR plaque was erected in 1922, and the second was a rededication in 1994 of Lincoln's circuit riding as well as a commemoration of the centennial of the founding of the local DAR. Lincoln's Gettysburg Address is etched on another plaque. Details of the other kiosk plaques are noted elsewhere in this book.

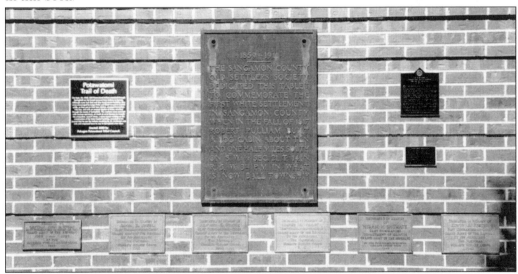

OLD STATE CAPITOL

HAS BEEN DESIGNATED A
REGISTERED NATIONAL
HISTORIC LANDMARK

UNDER THE PROVISIONS OF THE
HISTORIC SITES ACT OF AUGUST 21, 1935
THIS SITE POSSESSES EXCEPTIONAL VALUE
IN COMMEMORATING AND ILLUSTRATING
THE HISTORY OF THE UNITED STATES

U.S. DEPARTMENT OF THE INTERIOR
NATIONAL PARK SERVICE

The Old State Capitol is recognized on two plaques on the north side of the plaza kiosk. One commemorates the building's 1962 designation as a registered national historic landmark by the U.S. Department of Interior (above), and the other notes that both Abraham Lincoln and Ulysses S. Grant used the building before they were elected to the presidency (below). At the onset of his career, Grant served as a military aide to Gov. Richard Yates in the Old State Capitol. In this building, Lincoln tried cases before the Illinois Supreme Court, delivered his "house divided" speech, and lay in state after his assassination.

IN THE OLD STATE CAPITOL NEARBY,
PRESIDENT - ELECT ABRAHAM LINCOLN
USED THE GOVERNOR'S OFFICE AS HEADQUARTERS
UNTIL HE LEFT FOR WASHINGTON.
EARLY IN THE CIVIL WAR,
ULYSSES S. GRANT
ALSO SERVED HERE AS SPECIAL MILITARY AIDE
TO GOVERNOR YATES.

DURING THE WAR, ILLINOIS CONTRIBUTED
225,300 MEN,
ABOUT ONE-TENTH OF THE UNION'S FORCES;
MORE THAN 5,000 CAME FROM SANGAMON COUNTY.

In 1859, Lincoln and several other early settlers organized Springfield's Old Settlers Society. To celebrate the county's pioneer past, an Old Settlers' Day was inaugurated on October 20 with ceremonies at the site where Robert Pulliam, a Virginia transplant, built the county's first log cabin in 1817. This plaque can be found on the east wall of the kiosk on the Old State Capitol Plaza.

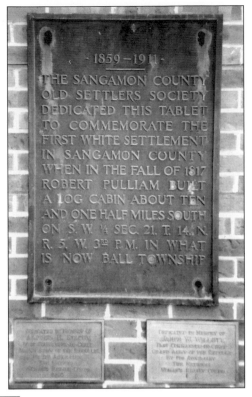

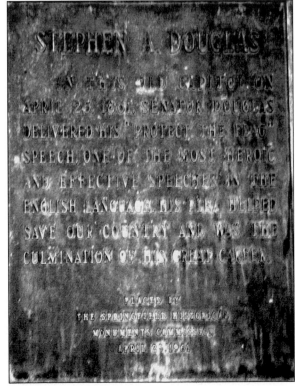

This plaque on the north wall of the plaza kiosk commemorates Stephen A. Douglas's "protect the flag" speech given in the Representatives Hall in the Old State Capitol on April 25, 1861. It was an eloquent plea to the crowd to put aside political differences to save the Union. Douglas died of typhoid within weeks after the speech.

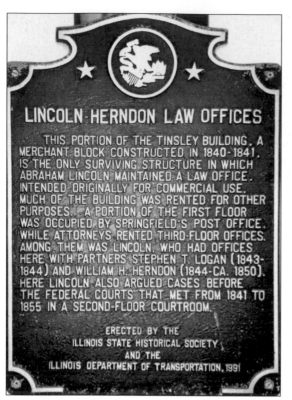

This plaque identifies the Tinsley Building on Sixth and Adams Streets in which Abraham Lincoln rented space with Stephen T. Logan and his third partner, William Herndon. The federal courtroom where Lincoln argued many cases was on the second floor. The building was restored in 1968 and purchased by the State of Illinois in July 1985. It is open for public tours.

This plaque on the north side of the Chase Bank at Sixth and Washington Streets identifies the site of the Sangamon County Courthouse where Lincoln argued more than 2,500 cases from 1846 until his nomination for the presidency in 1860. Like other frontier lawyers, Lincoln pleaded diverse cases such as disputes over land or animals, complaints about physical assault or slander, and routine debt suits.

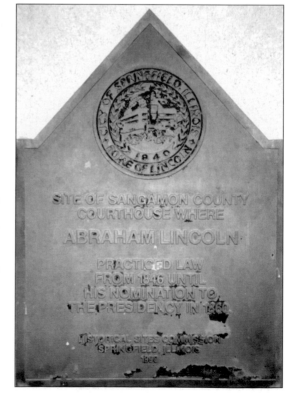

This plaque at 109 North Fifth Street signifies the location of the office that Lincoln shared with his first law partner, John Todd Stuart. The partnership was announced in the *Sangamo Journal*: "Attorneys and Counsellors at Law, will practice, conjointly, in the Courts of this Judicial Circuit.—Office No. 4 Hoffman's Row, up stairs, Springfield, April 12, 1837." (Courtesy of Sangamon Valley Collection, Lincoln Library.)

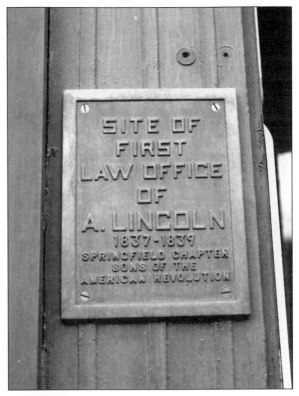

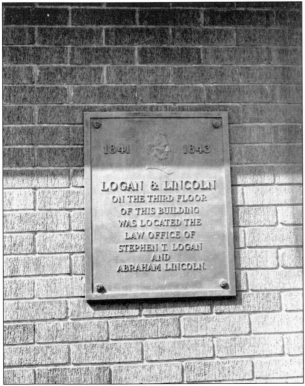

Lincoln and his second partner, Stephen T. Logan, practiced law from the third floor of this building at 203 South Sixth Street. Like Lincoln, Logan was a migrant from Kentucky who became a successful Springfield lawyer and politician. Their partnership from 1841 to 1844 was dissolved amicably when Logan created a new partnership with his son David. (Courtesy of Sangamon Valley Collection, Lincoln Library.)

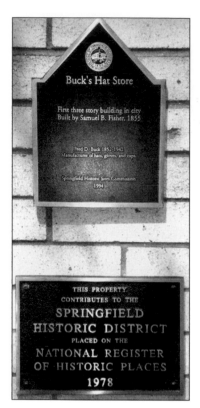

Dating from 1855, the building at 527 East Washington Street marked by this plaque is one of the oldest structures in downtown Springfield. After Fred Buck purchased it in 1883, the first floor of the building served as a men's clothing store until 1969. Other tenants included a dentist, doctor, dance instructor, and James Matheny, lawyer and the best man at Abraham Lincoln's wedding. Some original features of the building remain.

This plaque acknowledges the elite American House Hotel built on the southeast corner of Sixth and Adams Streets in 1837 by early entrepreneur Elijah Iles. Directly across the street from the state capitol, it served as a gathering place for legislators and visiting dignitaries. In addition to housing social events, the largest hotel in Illinois of that day was the site of the first professional theater company performance in Springfield.

Two Lincoln statues erected in 2006 are in Union Square Park, across the street from the Abraham Lincoln Presidential Library and Museum. Decatur sculptor John McClarey created *A Greater Task* located on the southeast corner of the square (right). He took the title from president-elect Lincoln's farewell speech to Springfield in which he spoke of the greatness of the task ahead. Dedicated on August 11, 2006, the A-i-A commissioned bronze shows Lincoln "ready to make a change, to start a new journey." The relaxed Lincoln (below) seated in the southwest corner of the park is one of 12 replicas created by Colorado artist Mark Lundeen. He fashioned a casual Lincoln to contrast with the formal portrayals seen in many statutes. Rick Lawrence, president of the company that constructed tthe Abraham Lincoln Presidential Library and Museum, purchased and donated the sculpture in honor of all the workers who contributed to the project.

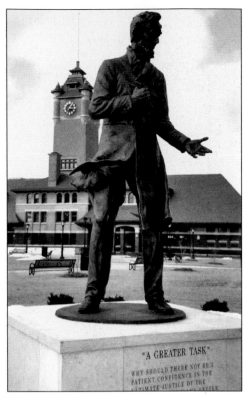

"A GREATER TASK"

WHY SHOULD THERE NOT BE A
PATIENT CONFIDENCE IN THE
ULTIMATE JUSTICE OF THE

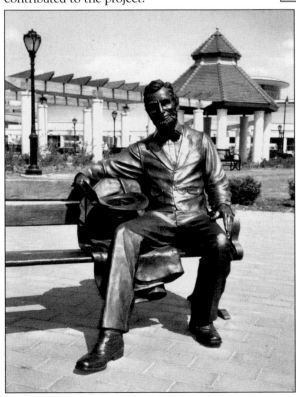

The site of the first home of Abraham and Mary Lincoln is memorialized by this plaque on a boulder on Adams Street near the Third Street railroad tracks. Lincoln wrote to his friend Joshua Speed, "boarding at the Globe Tavern, which is very well kept now by a widow lady of the name of Beck. Our room and boarding only costs four dollars a week." The Lincoln's eldest son, Robert, was born there.

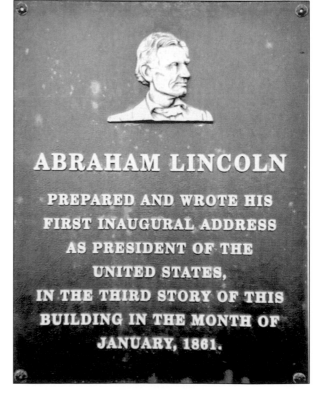

In late December of 1860, Lincoln moved his office to a vacant room over the store of C. M. Smith at 528 East Adams Street. Although he greeted most visitors in the Illinois State Capitol, he used the privacy of the office to work on his inaugural address in anticipation of his move to Washington.

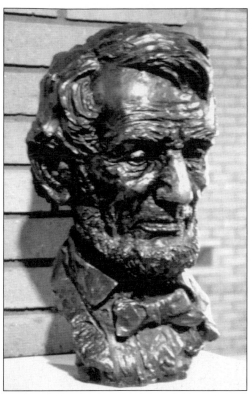

Two bronze artworks are in the Lincoln Home Visitor Center: a bust of Abraham Lincoln by Jo Davidson (right) and a plaque by Victor D. Brenner (below). The plaque is a cast from the original plaster submitted to the mint for the creation of the Lincoln penny. It was donated to the National Park Service by Mr. and Mrs. Edgar H. Hermmer in 1991. The bust was created in 1947 and donated in 1983 by the White House Preservation Fund and Dr. Maury Leibovitz. The visitor center at 426 South Seventh Street is the starting point for tours of the Lincoln Home National Historic Site. The site has been a unit of the National Park Service since 1972.

HARRIET DEAN HOUSE

In 1838, Abraham Lincoln purchased two lots in this block for $300. Twelve years later, he sold a half lot to Harriet Dean for $125.00. Mrs. Dean purchased an adjacent lot from someone else and had a house built, thus becoming a neighbor of the Lincolns.

The Lincoln Home National Historic Site is a four block area bordered by Capitol Avenue, Seventh, Ninth, and Edwards Streets. The preserved house that was the Lincoln family home from 1844 to 1861 stands at the center of the neighborhood at Eighth and Jackson Streets. The National Park Service is maintaining the exteriors of the other houses as they were in 1860, one year before Abraham Lincoln went to Washington. The interiors are adapted for contemporary uses. According to the 1860 census, there were 25 houses on Eighth Street that year. Today there are 12 at various stages of preservation. Plaques in front of each house describe historic details about the 1860 occupants. Visitors experience the ambience of 19th-century Springfield as they walk under "gaslights" on boardwalks and unpaved streets and read about Lincoln's neighbors. They discover that this community was a diverse cross section of citizens. For example, divorcee Harriet Dean, abandoned by her California gold–seeking husband, struggled to support herself and her son as a teacher and amateur botanist at the home across the street from the more affluent Lincolns.

SARAH COOK HOUSE

During 1860, this house was rented to Mrs. Cook, a widow, who let rooms to help provide support for herself and her children. In 1855, a Springfield newspaper carried an advertisement for Mrs. Cook's photographic studio, with its "splendid Camera, beautiful stock, and the best light in the city."

The Lincoln home was spacious compared to some of the other houses in their neighborhood. For instance, according to the 1860 census, the following people lived in the Cook house: Sarah Cook, Mary Cook, Hamilton Cook (student), Elbridge Cook (student), Lucinda Cook, Louisa Cook (six months old), and James (merchant) and Julia Gormley.

CHARLES CORNEAU HOUSE

This was the residence of Lincoln's friend, Charles Corneau, a Springfield druggist. Historic records show that the Lincoln family purchased such items as "Cough Candy," "Castor Oil," and "Hair Balsam" at the Corneau and Diller drugstore. Like Lincoln, Corneau was active in the Whig political party.

When the National Park Service acquired the Lincoln neighborhood site, the Corneau house was adjacent to the Lincoln home. In their efforts to restore the neighborhood to the 1860 era, the National Park Service relocated the Corneau house to its original site (the diagonal corner from the Lincoln home), and reconstructed a barn and privy on the property. Built in 1849, the house is on the National Register of Historic Places.

JULIA SPRIGG HOUSE

Mrs. Sprigg, a widow, purchased this house in 1853 and used it as a residence for herself and her children until 1869.

She became close friends with her neighbor, Mrs. Lincoln; Mrs. Sprigg's daughter often babysat for the younger Lincoln boys.

During Abraham Lincoln's long absences while on the judicial circuit, his wife Mary undoubtedly found companionship with the women of the neighborhood. Among Mary's friends was Julia Sprigg who was born in Germany but was widowed in the United States. Her small wooden frame house was built in 1851 by John B. Weber.

GEORGE W. SHUTT HOUSE

In 1860, this house was rented to young lawyer George Shutt and his family. Unlike most of Lincoln's politically active neighbors, Shutt supported Stephen A. Douglas in his campaign against Lincoln for the Presidency in 1860.

The George W. Schutt family was new to the neighborhood in 1860. Records indicate that William Jones sold the house to E. Allen in May 1860, and Allen rented it to Shutt. The Shutt family only stayed in the neighborhood for a few years because they built a home at Sixth and Allen Streets in 1864.

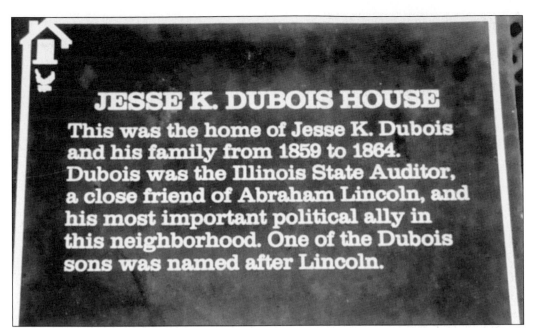

JESSE K. DUBOIS HOUSE

This was the home of Jesse K. Dubois and his family from 1859 to 1864. Dubois was the Illinois State Auditor, a close friend of Abraham Lincoln, and his most important political ally in this neighborhood. One of the Dubois sons was named after Lincoln.

When Jesse Dubois was elected to the position of state auditor, he purchased a home a half block south of the home of his friend Abraham Lincoln and moved his family to Springfield. The family remained there for five years and then purchased a home at 1225 West Washington Street. An elementary school built a block away from the site of the Washington Street residence is named for Lincoln's old neighbor.

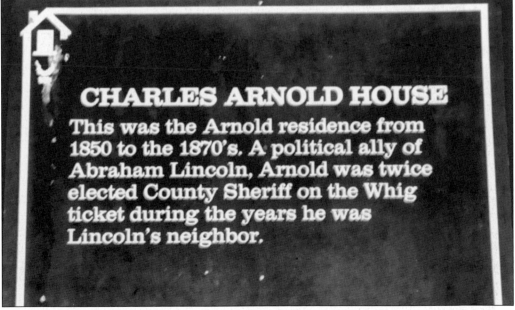

CHARLES ARNOLD HOUSE

This was the Arnold residence from 1850 to the 1870's. A political ally of Abraham Lincoln, Arnold was twice elected County Sheriff on the Whig ticket during the years he was Lincoln's neighbor.

This house in Lincoln's neighborhood was built in 1839 by Francis Springer, ordained Lutheran minister, Civil War chaplain, and educator. Because they moved to Hillsboro in 1847, the Springers were Lincoln neighbors for only three years. The Arnold family of six moved into this house across the street from the Lincolns in 1850. Arnold listed his occupation as a miller in the 1860 census.

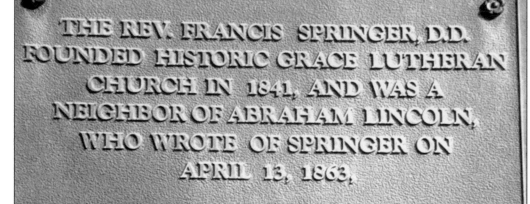

THE REV. FRANCIS SPRINGER, D.D.
FOUNDED HISTORIC GRACE LUTHERAN
CHURCH IN 1841, AND WAS A
NEIGHBOR OF ABRAHAM LINCOLN,
WHO WROTE OF SPRINGER ON
APRIL 13, 1863,

"FRANCIS SPRINGER IS ONE
OF MY BEST FRIENDS, & THAN
WHOM THERE IS NO MORE
RELIABLE MAN."
A. LINCOLN

This plaque is on Grace Lutheran Church, located on the southeast corner of Seventh Street and Capitol Avenue. In 1841, this congregation was founded by Francis Springer. The first Lutheran services in Springfield were held in the Springer home across Jackson Street from Lincoln's home. The present church structure, built in 1893, is on property owned by the National Park Service.

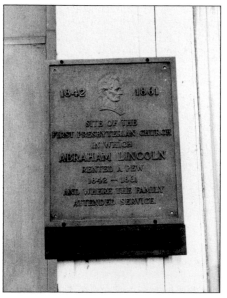

This plaque can be found at the site of the Lincoln family church, which is currently a tavern at 300 East Washington Street. The pew from the original church that records indicate was purchased by the Lincoln family is on display at the present First Presbyterian Church on the northwest corner of Seventh Street and Capitol Avenue.(Courtesy of Sangamon Valley Collection, Lincoln Library.)

The Looking for Lincoln Heritage Coalition (LLHC) is a consortium of central Illinois communities whose purpose is to create a Lincoln experience throughout central Illinois. Among the project's several components is a plaque network. Plaques with the LLHC logo are found throughout each community. Each plaque provides some historical facts or stories that give context to Lincoln and his world. Dozens of LLHC plaques are found throughout Springfield. The pictured plaque on West Washington Street identifies the site of the Chenery House, a hotel purchased and "updated" in 1855 by John W. Chenery, the former manager of the renowned American House. Chenery House amenities included gas lamps and a bell for summoning servants in each of the 130 rooms. After a farewell reception for the Lincoln family in their home on February 6, 1861, they moved to the Chenery House where they stayed until they left for Washington, D.C., on February 11.

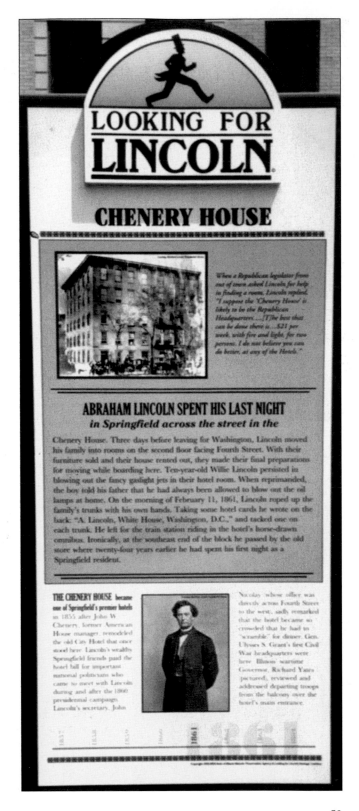

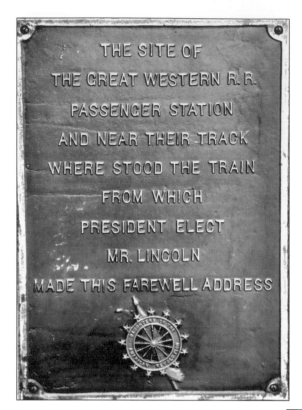

THE SITE OF
THE GREAT WESTERN R.R.
PASSENGER STATION
AND NEAR THEIR TRACK
WHERE STOOD THE TRAIN
FROM WHICH
PRESIDENT ELECT
MR. LINCOLN
MADE THIS FAREWELL ADDRESS

When Abraham Lincoln left Springfield for Washington, D.C., on February 11, 1861, to become the 16th president, he bid farewell to the city with a short emotional speech that has become known as his "farewell address." The complete text of that message is found on a plaque embedded in a rock in front of the restored Great Western Depot at Tenth and Monroe Streets (below). On the opposite side of the stone is a plaque marking the site of the Great Western Railroad station (left) where his inaugural train stood. Since 1987, the depot is an interpretive visitor's center staffed by National Park Service rangers under a cooperative agreement with the owners of the *State Journal-Register*.

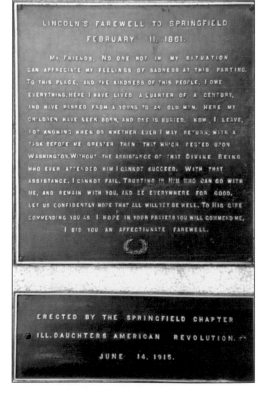

Three

WHERE SPRINGFIELD LIVES
AROUND THE TOWN

Springfield is many things more than Abraham Lincoln's hometown and the seat of Illinois government. To the early settlers, it was a hunter's paradise with lush vegetation fed by Spring Creek. For them and for future Springfield residents like Lincoln, it was a place for beginnings. The family of George Donner started its historic journey to California from Springfield. The Springfield Maid-Rite was one of the first franchises and drive-through restaurants in the United States. Poet Vachel Lindsay found his muse in his hometown and went on to national fame.

Springfield citizens value their arts and leisure activities. Businesses use original sculptures as their corporate symbols. Individuals and organizations invest in public art for the benefit of the entire community. Surviving examples of early-20th-century prairie school works by two of the most prominent leaders of the movement, Frank Lloyd Wright and Jens Jensen, are preserved in Springfield. An Illinois historic site, the Dana-Thomas House is the most complete of Wright's surviving early prairie-style homes. Landscape architect Jensen's 1936 prairie plan for Lincoln Memorial Garden is still maintained today for the pleasure of visitors. The community provides many other diversions. For example, Springfield annually hosts the Illinois State Fair. The Henson Robinson Zoo displays more than 90 species of native and exotic animals.

As it was in Lincoln's day, Springfield is a place where individuals can make a difference. During the first half of the 20th century, the Spaulding brothers improved the local water system and impacted community water systems throughout the world. In 1991, two young school girls set in motion a successful campaign to raise the awareness of Springfield's infamous race riots. Finally, Springfield is a place that honors the community's significant people and events. The sculptures, monuments, and plaques found throughout the city and pictured in this chapter document and celebrate the unique character of Springfield, Illinois.

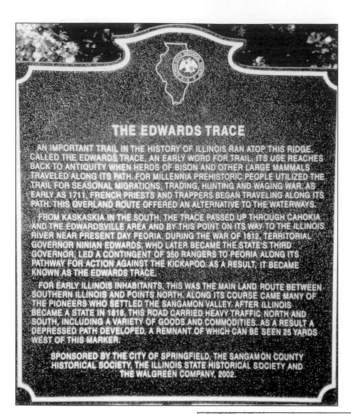

THE EDWARDS TRACE

AN IMPORTANT TRAIL IN THE HISTORY OF ILLINOIS RAN ATOP THIS RIDGE. CALLED THE EDWARDS TRACE, AN EARLY WORD FOR TRAIL, ITS USE REACHES BACK TO ANTIQUITY WHEN HERDS OF BISON AND OTHER LARGE MAMMALS TRAVELED ALONG ITS PATH. FOR MILLENNIA PREHISTORIC PEOPLE UTILIZED THE TRAIL FOR SEASONAL MIGRATIONS, TRADING, HUNTING AND WAGING WAR. AS EARLY AS 1711, FRENCH PRIESTS AND TRAPPERS BEGAN TRAVELING ALONG ITS PATH. THIS OVERLAND ROUTE OFFERED AN ALTERNATIVE TO THE WATERWAYS.

FROM KASKASKIA IN THE SOUTH, THE TRACE PASSED UP THROUGH CAHOKIA AND THE EDWARDSVILLE AREA AND BY THIS POINT ON ITS WAY TO THE ILLINOIS RIVER NEAR PRESENT DAY PEORIA. DURING THE WAR OF 1812, TERRITORIAL GOVERNOR NINIAN EDWARDS, WHO LATER BECAME THE STATE'S THIRD GOVERNOR, LED A CONTINGENT OF 350 RANGERS ALONG ITS PATHWAY FOR ACTION AGAINST THE KICKAPOO. AS A RESULT, IT BECAME KNOWN AS THE EDWARDS TRACE.

FOR EARLY ILLINOIS INHABITANTS, THIS WAS THE MAIN LAND ROUTE BETWEEN SOUTHERN ILLINOIS AND POINTS NORTH. ALONG ITS COURSE CAME MANY OF THE PIONEERS WHO SETTLED THE SANGAMON VALLEY. AFTER ILLINOIS BECAME A STATE IN 1818, THIS ROAD CARRIED HEAVY TRAFFIC NORTH AND SOUTH, INCLUDING A VARIETY OF GOODS AND COMMODITIES. AS A RESULT A DEPRESSED PATH DEVELOPED, A REMNANT OF WHICH CAN BE SEEN 25 YARDS WEST OF THIS MARKER.

SPONSORED BY THE CITY OF SPRINGFIELD, THE SANGAMON COUNTY HISTORICAL SOCIETY, THE ILLINOIS STATE HISTORICAL SOCIETY AND THE WALGREEN COMPANY, 2002.

Many early settlers arrived in the area by following the north–south land route called the Edwards Trace, so named because Ninian Edwards led a force of rangers on the trail prior to the War of 1812. Worn by horses, buffalo hooves, and pioneer wagon wheels, the trail was known to English speaking settlers as early as 1763. A remnant of it was discovered and marked in Springfield's Center Park in 2002.

After hunter-trader Elisha Kelly discovered the bounties of this area in 1818, he returned to North Carolina and convinced his father and four brothers to settle here. This plaque, just west of Second Street on Jefferson Street, marks the site of the cabin of Elisha's brother John. Purported to be the first home constructed in Springfield, the building also became the political and judicial center of the new community.

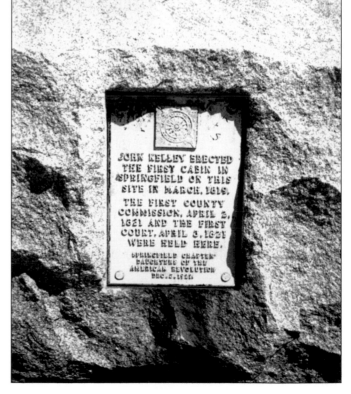

The home of Springfield's first entrepreneur, Elijah Iles, is the oldest standing house in Springfield. The Greek Revival house was moved to South Fifth Street in 1910 and returned in 1998 to Lincoln's neighborhood at Seventh and Cook Streets. After extensive renovation by the Iles House Foundation, it now serves as a museum and conference center. It was placed on the National Register of Historic Places in 1978.

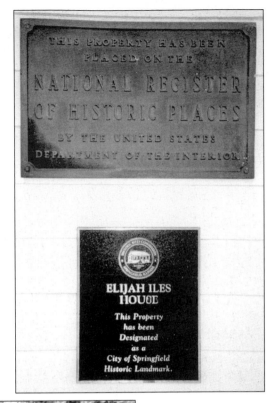

HERE IN 1821 WAS BUILT THE
FIRST SCHOOL IN SPRINGFIELD.

SCHOOL MASTER:

1821 — 1822 ANDREW ORR
1822 — 1824 ERASTUS WRIGHT
1824 — 1826 WILLIAM MENDENHALL
1826 — 1827 THOMAS MOFFETT

ERECTED BY SPRINGFIELD
CHAPTER, DAUGHTERS OF THE
AMERICAN REVOLUTION
APRIL 19, 1918.

Affixed to a stone beneath the flag pole in front of Springfield High School is the marker that identifies Springfield's first school. Built in 1821, the school was a 14-by-16-foot cabin of round logs with a single door and rough boards for benches and desks. Admission to the school, which was in use until 1829, ranged from $1.50 to $3 per student for an 11-week term.

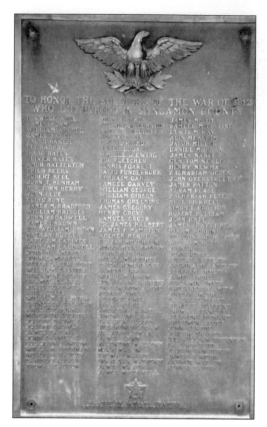

TO HONOR THE SOLDIERS OF THE WAR OF 1812
WHO LIE BURIED IN SANGAMON COUNTY

Soldiers of two early wars are honored on two plaques on the north wall of the plaza kiosk. Twenty-four names of men who served in the American Revolution and are buried in Sangamon County are listed on the plaque on the right side of the wall (below). The plaque was donated in 1911 by the Sons and Daughters of the American Revolution of Sangamon County with three more names added in 1914. On the left side of the wall is a plaque honoring soldiers who died in the War of 1812 and are buried in Sangamon County (left). One hundred and thirty-three names are listed by the Sangamon Chapter of the United States Daughters of 1812.

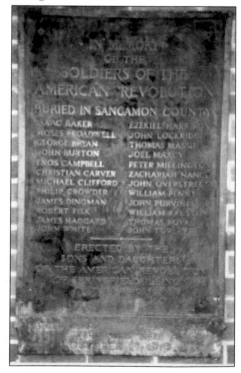

Thirty-three Springfield residents departed from their hometown on April 15, 1846, for the long trek to California. The ill-fated journey of the Donner party has become an American legend, and their departure is commemorated by this plaque on the north wall of the plaza kiosk. It was presented by the W. Bose Society of the Children of the American Revolution on April 15, 1957.

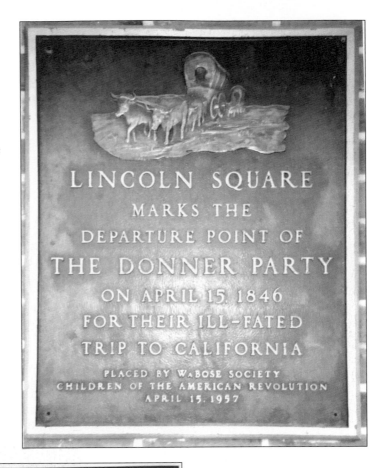

LINCOLN SQUARE
MARKS THE
DEPARTURE POINT OF
THE DONNER PARTY
ON APRIL 15, 1846
FOR THEIR ILL-FATED
TRIP TO CALIFORNIA
PLACED BY W. BOSE SOCIETY
CHILDREN OF THE AMERICAN REVOLUTION
APRIL 15, 1957

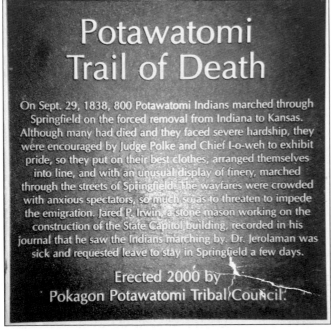

Potawatomi Trail of Death

On Sept. 29, 1838, 800 Potawatomi Indians marched through Springfield on the forced removal from Indiana to Kansas. Although many had died and they faced severe hardship, they were encouraged by Judge Polke and Chief I-o-weh to exhibit pride, so they put on their best clothes, arranged themselves into line, and with an unusual display of finery, marched through the streets of Springfield. The wayfares were crowded with anxious spectators, so much so, as to threaten to impede the emigration. Jared P. Irwin, a stone mason working on the construction of the State Capitol building, recorded in his journal that he saw the Indians marching by. Dr. Jerolaman was sick and requested leave to stay in Springfield a few days.

Erected 2000 by
Pokagon Potawatomi Tribal Council.

This plaque hangs on the east wall of the plaza kiosk. Erected in 2000 by the Pokagon Potawatomi Tribal Council, it tells details of the march of 800 Potawatomi Indians through Springfield on September 29, 1838. They were a part of the forced removal from Indiana to what is today Kansas. Descriptions of the event are taken from contemporary journals and recorded on the plaque.

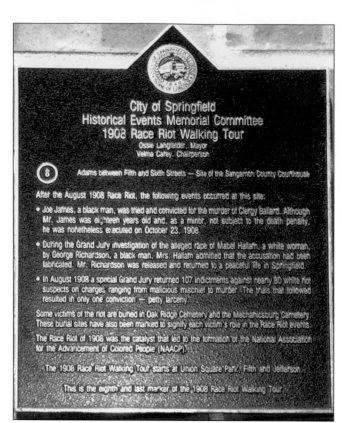

On August 14, 1908, a two-day race riot erupted in Springfield. Lynchings and violent property destruction brought the Illinois militia to the city. Although the riot is considered the event that led to the founding of the NAACP, it was virtually unnoticed until 1991 when two 11-year-old girls brought it to the attention of the city council. After learning of the riots through a history project, Amanda (Londrigan) Staab and Lindsay (Price) Harney (below) petitioned the council for a memorial "so that we can learn from the past." Today eight markers along the path of destruction tell the story. The first marker is at Seventh and Jefferson Streets, the site of the old county jail, and the eighth marker is on the east wall of the Old Capitol Plaza kiosk (left). (Below, courtesy of Sangamon Valley Collection, Lincoln Library.)

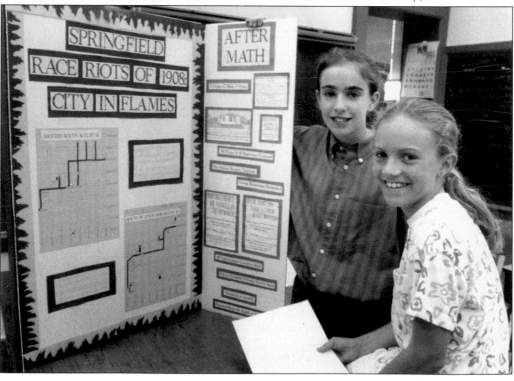

On the sidewalk adjacent to Christ Episcopal Church at 611 East Jackson Street is a tree with a plaque honoring Christian Porter. Porter was killed in the Persian Gulf War in 1991 at the age of 21. He was baptized, attended Sunday school, and served as acolyte at the church. His burial services were also held there. The plaque and tree were donated by Ursuline Academy, his alma mater.

Editorial without Words is a statue of the symbol of the Shriners' Hospitals. Originally, the image was a photograph taken by Randy Dieter in 1970 at a Shriners' event in Evansville, Indiana. It has been reproduced in stained-glass windows, mosaics, and pins. The Springfield statue was purchased by George R. and Charlene Kennedy in 2000 and stands in front of the Ansar Shrine Center at 630 South Sixth Street.

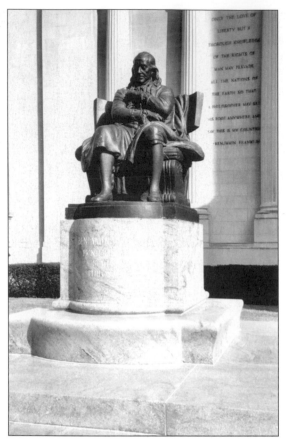

The massive statue of Benjamin Franklin (left) sits in the front courtyard of the South Sixth Street building that was once the headquarters of the Franklin Life Insurance Company. The 2007 owners, American International Group, sold the building to the State of Illinois to be used as headquarters for the Illinois State Police. The company donated the statue to the Illinois State Police Heritage Foundation to be incorporated into a state police memorial. The sculptor, James Earle Fraser, is internationally known. Famous works by him include the American Indian sculpture *The End of the Trail* and the design of the buffalo nickel. Pictured (below) are participants of the dedication ceremony on September 8, 1949: Charles Becker, president of Franklin Life; Ann Castle, descendent of Franklin; vice president Alben Barkley; Gov. Adlai Stevenson; and Fraser. (Below, courtesy of Sangamon Valley Collection, Lincoln Library.)

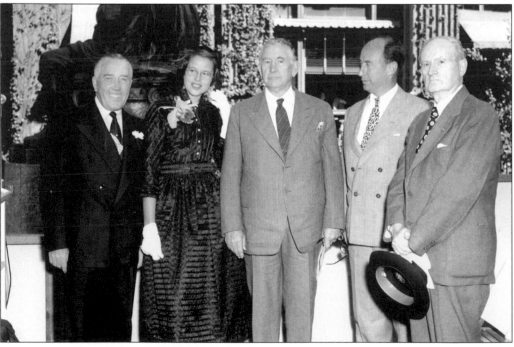

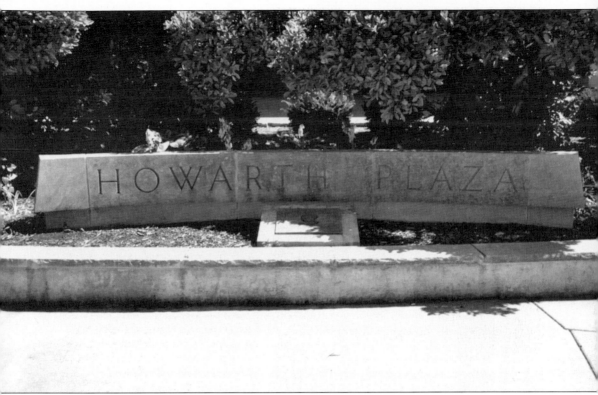

Howarth Plaza forms a small park in front of the Springfield Municipal Building on South Seventh Street. The plaza is bordered on the south by a 14-foot limestone arch and bronze plaque honoring Nelson Howarth, mayor of Springfield in 1955–1959 and 1963–1971. In his 12 years as mayor, he championed civil rights and impartial law enforcement. Howarth spearheaded several city expansion projects and promoted major initiatives such as the Prairie Capital Convention Center, the Old State Capitol restoration, and the creation of the Lincoln Home National Historic Site. The plaque includes a quote from Vachel Lindsay, poet and Springfield native son: "In this, the city of my discontent . . . we must have many Lincoln-hearted men." Several other monuments and markers are found on Howarth Plaza.

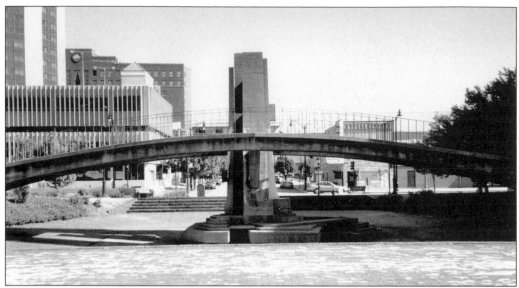

The Spaulding Fountain on Howarth Plaza was a gift to Springfield by the family of Charles Herbert Spaulding, Springfield native, inventor of the water precipitator, and brother of water commissioner Willis Spaulding. The family gave another fountain in his honor to the University of Illinois at Springfield. The designer of the plaza fountain was Earl "Wally" Henderson, a Springfield architect and city planner.

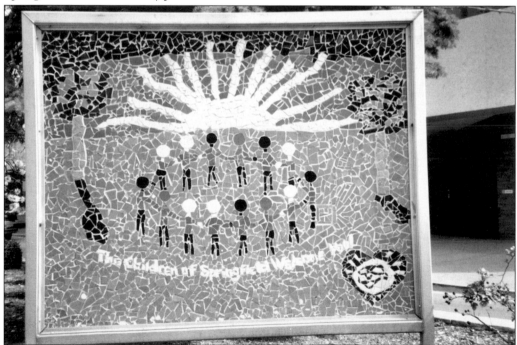

Camp Care-A-Lot is a non-profit residential camp in Springfield for children from low- or no-income families. The mosaic was designed by the visual art department of the University of Illinois at Springfield, and the tiles were laid by campers and volunteers. The work was a gift to the city of Springfield in honor of Camp Care-A-Lot's 10th anniversary. Dedicated in 2004, it stands on Howarth Plaza facing Seventh Street.

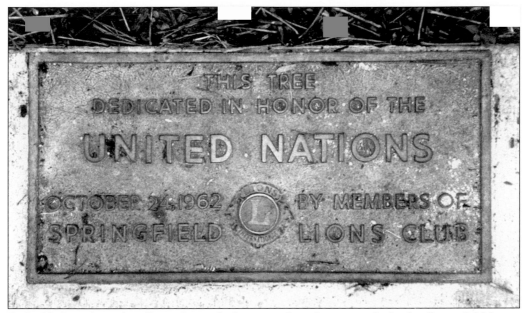

Embedded in the sidewalk on Seventh Street is this plaque in which the Springfield Lions Club honored the United Nations in 1962. The Springfield Lions Club is a service organization affiliated with Lions Club International, founded in Chicago in 1917. Lions Clubs International helped the United Nations form the Non-Governmental Organizations sections in 1945 and continues to hold consultative status with the United Nations.

In 1988, the Elwood Commandery No. 6, a Masonic organization, originally placed this tribute to Springfield's fallen police officers and fire fighters on Union Square. When the square was updated to accommodate visitors to the Abraham Lincoln Presidential Library and Museum, Springfield police and firefighter unions paid to replace the deteriorated plaque, and the memorial was moved to its present location on the Howarth Plaza on Seventh Street.

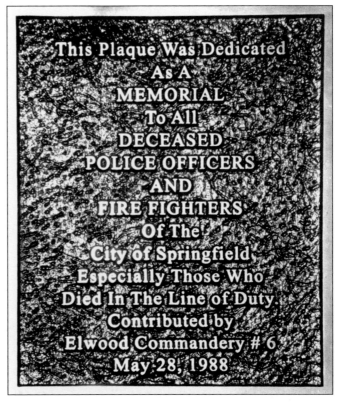

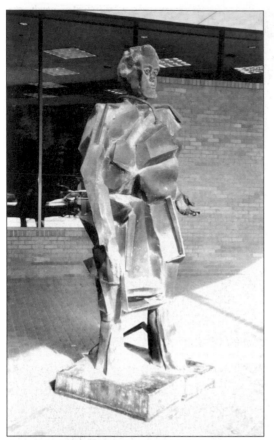

Two gifts to the city of Springfield from the board of directors of the Old Capitol Art Fair stand adjacent to Lincoln Library, Springfield's public library. *Abstract Lincoln* (left) was unveiled on November 21, 1976, at the Capitol Avenue entrance of the library. Selected from 22 competitors, the bronze sculpture was an attempt by the artist, Abbott Pattison, to link the historic Abraham Lincoln to the lines and shapes of the contemporary building. *Celebration* by Eugene Horvath (below) stands on a grassy area just east of the library. The artist was commissioned in 1986 to create the steel structure in commemoration of the 25th anniversary of the Old Capitol Art Fair.

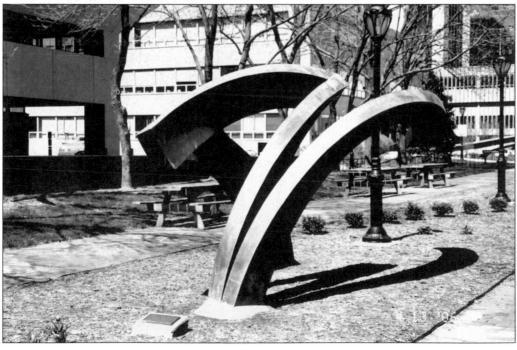

Flower in a Crannied Wall (above) greets visitors to the Dana-Thomas House at Fourth and Lawrence Streets. The house and its furnishings were designed for Springfield socialite and activist Susan Lawrence Dana by young architect Frank Lloyd Wright in 1902–1904. Created by Richard Bock, the terra-cotta statue has Alfred Tennyson's poem by the same name etched on her back. The poem conveys the reverence for nature that Wright and Tennyson shared. Wright also designed a library in the Lawrence School at 101 East Laurel Street to honor Dana's father (right). The library is still used by the students in the school. Furnishings in the current library are reproductions. The original Wright-designed furniture has been moved to Dana's home where Wright's furniture, light fixtures, and art glass can be seen by visitors on tour. (Above, courtesy of Doug Carr.)

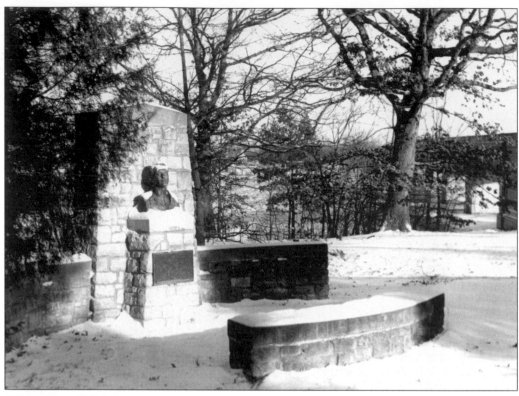

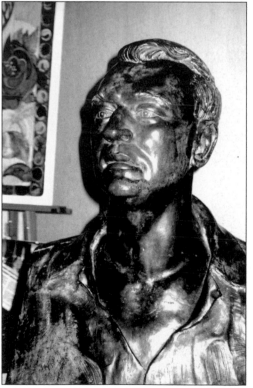

In 1935, a bronze bust of Springfield's "Prairie Troubadour," Vachel Lindsay, was placed in a small landscaped memorial at the west end of the Lake Springfield bridge named for the poet (above). After a series of vandalism attacks in the early 1960s, the bust was removed from its outdoor setting and restored to its original condition through the efforts of its sculptor, Adrien A. Voisin of San Francisco, and restorer Gustav Napier. The repaired bust (left) can be viewed by visitors in Lindsay's birthplace at 603 South Fifth Street. The Lindsay home was originally owned by Clark M. Smith and his wife Ann (younger sister of Mary Todd Lincoln). Lindsay's parents bought the house in 1878. Many of Lindsay's artifacts and artworks as well as original fixtures and furnishings are on display in the home. (Above, courtesy of Sangamon Valley Collection, Lincoln Library.)

Since 1929, two sculptured panels by Iowa artist Nellie Walker have flanked the doors of Springfield's water plant. Originally on the front of the Water Purification Building on the Sangamon River (below), *Health* and *Happiness* were moved to the current filter plant on Lake Springfield in the mid-1930s (right). The plaques above the doors read: "Monument to the ability of the people to serve themselves and build for posterity," by George Johnson. Pictured in front of the "new" water plant is Willis Spaulding, superintendent of the Springfield Water Works from 1909 to 1911 and commissioner of public property from 1911 to 1943. During his tenure, he spearheaded an improved water system, created the publicly owned electric utility and placed it on a paying basis, and led the movement for the creation of Lake Springfield. (Courtesy of Sangamon Valley Collection, Lincoln Library.)

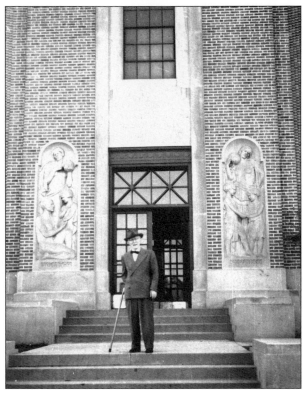

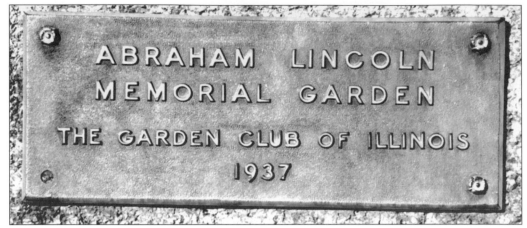

Lincoln Memorial Garden encompasses a 63-acre site on the shores of Lake Springfield. Designed in 1936 by America's foremost landscape architect Jens Jensen, the garden includes plants that are native to the three states where Lincoln lived (Kentucky, Indiana, and Illinois). It is a classic example of Jensen's prairie-style design work. The indigenous plants are one of his hallmarks as is the natural stone in the eight council rings. His paths meander through arrangements of plants, groves of trees, and open meadows of prairie flowers. A plaque affixed to a stone greets visitors at the garden entrance (above), and another plaque, honoring Harriet Knudson, the member of the Springfield Civic Garden Club who spearheaded this living tribute to Lincoln, is embedded in the sidewalk a few steps beyond (below).

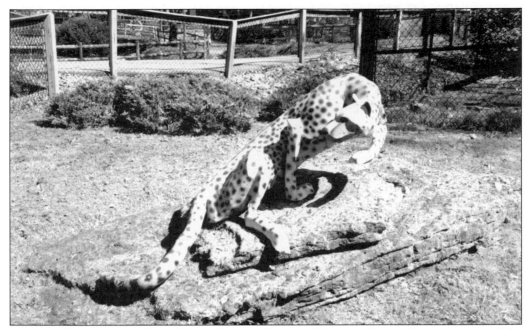

Native and exotic animals are housed in the Henson Robinson Zoo, a 14-acre area on Lake Springfield. The Henson Robinson name has been prominent in Springfield since March 13, 1861, when the first Henson Robinson began selling tin roofing, kettles, and cooking and heating stoves. The Henson Robinson Company continued under the leadership of several Robinson generations and is currently a Springfield heating and cooling establishment. Dedicated in 1970, the zoo was named after the grandson of the original Robinson, Henson C. Robinson, who first sought to bring a zoo to Springfield. Two commemorative sculptures by Jeff Garland stand near the zoo's central building. To honor the zoo's 25th anniversary, the Springfield Zoological Society presented the cheetah *Kuepa* on August 26, 1995 (above). A butterfly with aluminum and Plexiglas wings memorializes Phillip L. Robinson, founder of the zoo (below).

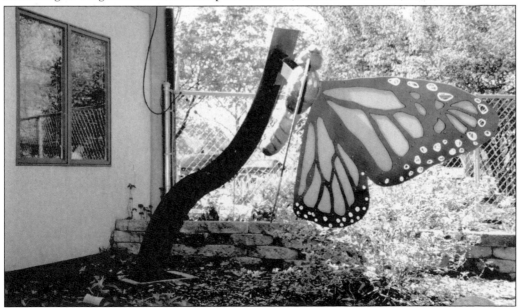

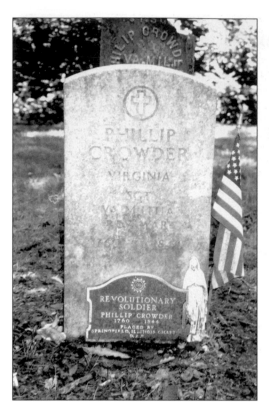

Phillip Crowder, Revolutionary War veteran, is buried on a small plot of land on Chatham Road near Fair Oaks Circle. Born in Virginia in 1759, Crowder volunteered for service at age 16. He moved with his family to Sangamon County at the age of 71 in 1830. Crowder fathered 15 children with his three wives. The plot is maintained by volunteers with support from the city of Leland Grove.

Niccolls Stone Yard by Michael Dunbar stands in a quiet neighborhood in front of 1050 Williams Boulevard. Created in 1977, this welded steel structure is the first large-scale sculpture by the nationally acclaimed artist. The title is in homage to Roscoe Niccolls, a retired stone contractor who rented his shop space to Dunbar for his first studio and became the young artist's friend and mentor. The piece is privately owned.

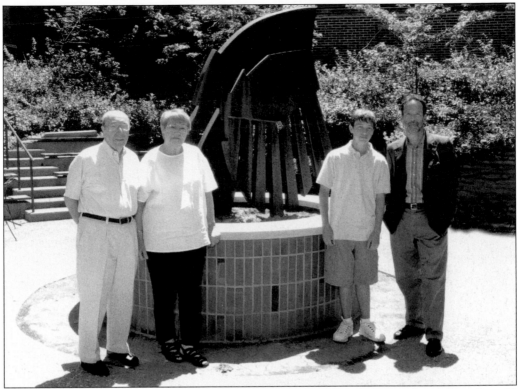

The steel sculpture *Smokestack Lightning* by Michael Dunbar, donated by Evelyn and Dr. Donald Yurdin and their son Bruce, stands in the Garden Courtyard on the lower level of Memorial Medical Center. The donation was in memory of Bruce's wife, Jill, who died of cancer in 2005. Pictured from left to right are Dr. Donald Yurdin, Evelyn Yurdin, grandson Jack, and son Bruce. (Courtesy of Memorial Medical Center Foundation.)

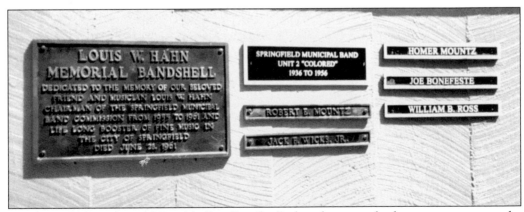

The Louis Hahn Memorial Bandshell in Douglas Park is the venue for free summer concerts by the Springfield Municipal Band. Publicly funded, the band has been the official musical group of the City of Springfield since 1936. The plaques on the bandshell's wall of honor recognize individuals who were significant in the history of the band.

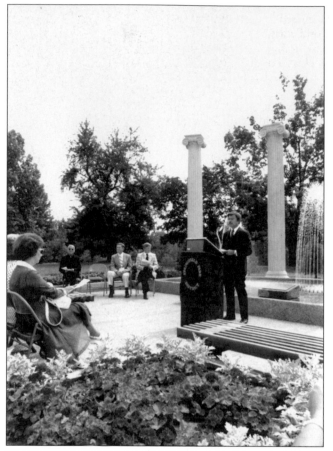

On August 26, 1979, Springfield's Roman Cultural Society presented to the Springfield Park District the ornamental pool and fountains at the Washington Park Horticulture Center. Central to the monument are the five ionic columns that had stood at the main entrance of Springfield's old Carnegie Library. Through the efforts of a citizens committee spearheaded by Ralph Bowen, the columns were saved when the Carnegie building was razed in 1974 for the new library. Speakers pictured at the dedication ceremony (left) are Fr. Joseph Canella, C.S.V., Ralph Bowen, Springfield Park District representative Patrick Flannigan, and Joe Alessandrini, president of the Roman Cultural Society at the podium. The ceremony was followed by a concert at the Thomas Rees Memorial Carillon. (Left, courtesy of Jo Ann Alessandrini.)

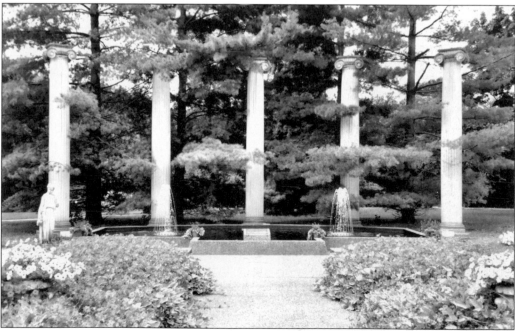

Springfield civic leader Thomas Rees created the Rees Memorial Fund to build a world-class carillon in Washington Park. The result is the 132-foot reinforced white concrete, steel, and brick tower surrounded at its base by a reflecting pool that was dedicated in 1962. The carillon houses 66 cast-bronze bells, which are played in regular concerts and at an international carillon festival each summer.

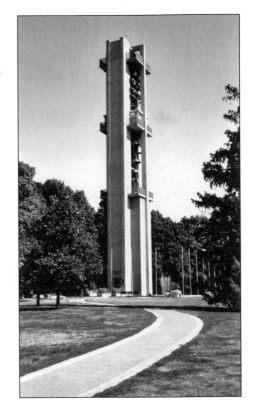

Henry Kirschner, founder of Springfield's Town and Country Bank, and Art Squires, founder of Squires Advertising Agency, designed the logo for the bank in 1964. Paul Reimer, artist and bank board member, sculpted the stainless steel figure for the bank headquarters at MacArthur Boulevard and Ash Street in the mid-1970s. The design is intended to symbolize the role of the bank in helping customers grow and reach their goals.

Creating stark contrast, two contemporary sculptures stand in the courtyard of the historic Edwards Place Italianate mansion (built 1833) at 700 North Fourth Street. Both works were designed for the Springfield Art Association, the current owner of the house. *True Love* (left) was a gift to the organization by the Riemer family in 1997. The galvanized steel structure was created by Paul Riemer at age 72 to honor his wife of over 50 years. Riemer, an iron worker by trade, began his career as an artist when he took a class from the Cooperative Extension Services of the University of Illinois at age 36. John Kearney's *Bicentennial Bison* (below) is constructed from welded chrome car bumpers. The sculpture was installed in March 1976, when Kearney was codirector of the Contemporary Workshop in Chicago.

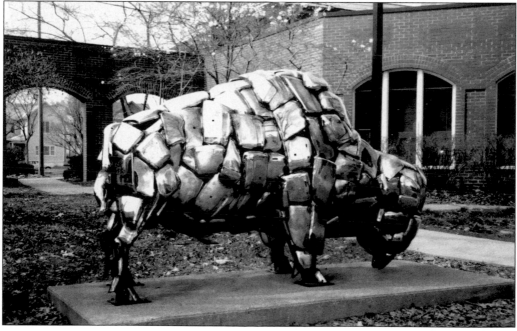

The World War I Memorial is found on the southeast corner of First Street and North Grand Avenue. Funded by an anonymous donor, the monument memorializes 113 soldiers from Sangamon County who died from 1917 to 1918 from injuries suffered in "the war to end all wars." The Arnold Monument Company of Springfield fashioned and engraved the barre granite piece, which was erected in October 2003.

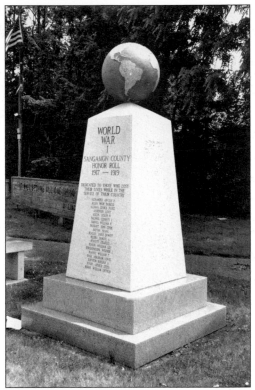

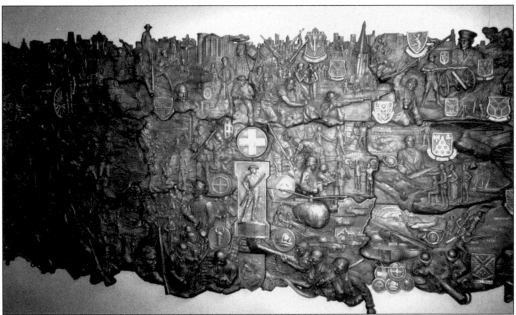

The Illinois State Military Museum at 1301 North MacArthur Boulevard houses a 14-by-6-foot *Bronze Wall* depicting information about the communities of 14 Illinois armories. Artist David Seagraves created 14 individual panels that interlock to create the larger work. Four panels portraying events in the history of the Illinois Militia and National Guard surround the minuteman at the center of the sculpture. The A-i-A commission was dedicated on May 12, 2005.

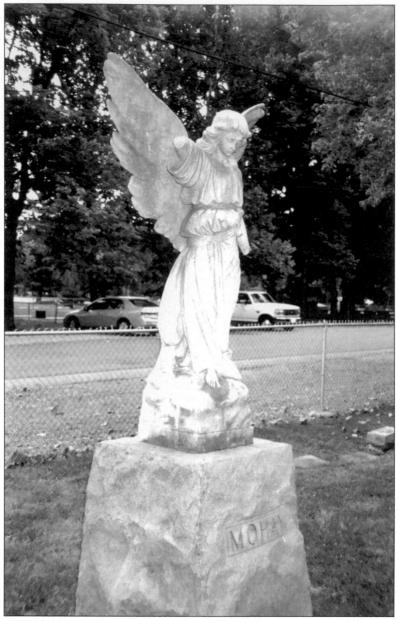

When the Springfield City Council decreed in 1855 that burials could no longer be conducted within the city limits, the city purchased land for Oak Ridge Cemetery, and German and Irish Catholics obtained property to create Calvary Cemetery. Calvary Cemetery and Oak Ridge Cemetery are now adjacent to each other. Tragically, documentation of early burials in Calvary Cemetery is limited because most of the cemetery records were destroyed or damaged in a fire at the end of the 19th century. The entrance to the 75-acre Calvary Cemetery, owned and maintained by the Roman Catholic Diocese of Springfield, is off of North First Street. An armless angel guarding a tombstone with the inscription of "Mohay" stands near the entrance on the east corner of the cemetery. Her back is toward North First Street and the adjacent Lincoln Park. Local folklore purports that she turns completely around at midnight on Halloween. Many young Springfield residents have conducted midnight vigils, but no one has witnessed the phenomenon.

Haitian-born William Florville is recognized primarily as Abraham Lincoln's barber and friend. In fact, in addition to cutting the hair of many Springfield citizens, Florville was a wealthy landowner, influential businessman, and civic leader. He is buried in Calvary Cemetery with his son Varveel who served in the Union Army in the Civil War. Florville's wife Phoebe and two of his other children rest in Oak Ridge Cemetery.

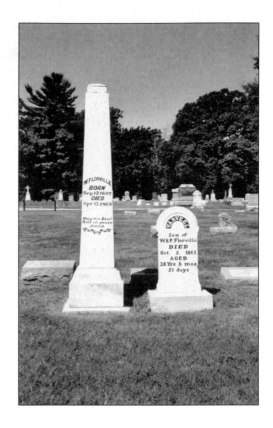

The monument of Harry Woods Phillips in Calvary Cemetery reads: "Died April 6, 1883, Aged 13 years, 2 months, 4 days." The stone is cut in the style of Edward Levanius whose many symbolic monuments are found in Oak Ridge Cemetery. The stone tree with broken limbs to symbolize a life cut short has a young boy's hat hanging on the side and a dejected dog clinging to the trunk.

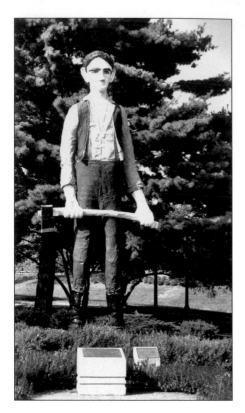

The Railsplitter, a 30-foot figure of young Abraham Lincoln, greets visitors at the entrance of the Illinois State Fairgrounds. Carl Rinnus, a Springfield department store window decorator, created the statue with fiberglass around a wire screen frame. The legs are fabricated around two telephone poles. This Lincoln has been a favorite photograph background for state fair visitors since 1967.

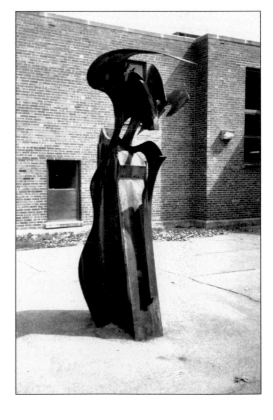

Dedicated in 1981 as an A-i-A commission, *Flight Simulations* found near Building 29 (the Home Economics Building) on the state fairgrounds, is the first large-scale sculpture of Preston Jackson. A professor at the School of the Chicago Art Institute, the highly respected artist received the Order of Lincoln Medallion in 1998, the state's highest honor for personal achievement. His work, found throughout Illinois, ranges from abstract to emotionally charged realism.

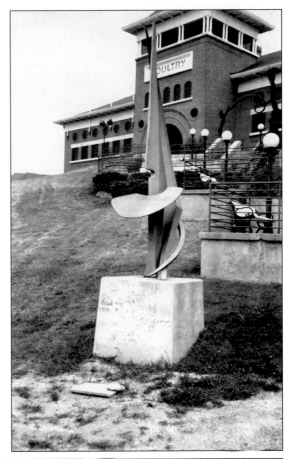

John Medwedeff, creator of *Half Side Jack* (below) and *The Zephyr* (right), forges site-specific public sculptures, sculptural fountains, architectural ironwork, and furniture. *The Zephyr* (1998) stands at the bottom of the steps leading to the poultry building, and *Half Side Jack* (1999) arches the top of the steps at the Illinois State Fairgrounds. Both are A-i-A commissions. Medwedeff says, "I am inspired by the botanical, aquatic, and atmospheric phenomena of my familiar landscapes. At the forge I have developed a visual vocabulary of movement and energy with which I explore, through metal, this natural world in relation to the body and to the architecture."

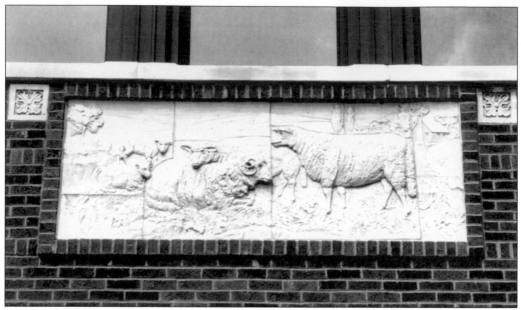

Two bas-relief images of sheep are attached to the outside walls of the Sheep Pavilion at the Illinois State Fairgrounds. According to a plaque below the sheep, the original building with the sculptures was built in 1912 by Springfield contractor J. F. Duncan. C. V. Lewis of Danville was the building architect. Another plaque commemorates the rebuilding of the Sheep Pavilion in 1990 under the leadership of Gov. James R. Thompson. The sculptures were saved and placed in their current position on the new building. The architect for the 1990 building was Steckel-Parker. The artist is not acknowledged on either plaque.

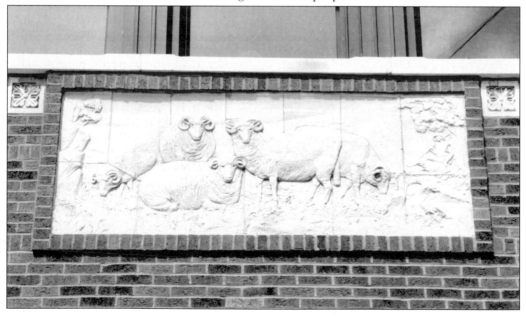

Four

WHERE THE FUTURE LEARNS
EDUCATIONAL INSTITUTIONS

Historically Springfield's elementary and secondary schools have incorporated strong local history and art programs in their curriculum. This fact is documented by sculptures and plaques on school grounds throughout the city. Students have made history by creating artworks in collaboration with artists, and they have recorded history for the community in partnership with historians. Additionally, important historic events and people are acknowledged on the property of several Springfield schools.

Several specialized institutions of higher education have come and gone in Springfield since the 1850s: Concordia Theological Seminary (1852–1976), Lincoln College of Law (1911 1929), Brown's Business College (1913–1994), and music and nursing schools. Since only Springfield Junior College, founded in 1929 by Ursuline nuns, provided a two-year liberal arts program to the community, options for a liberal arts education in Springfield were limited until the late 1960s. In 1967, however, Lincoln Land Community College was founded. That same year, Springfield Junior College became Springfield College in Illinois. Then in 1970, Sangamon State University opened its doors, and Southern Illinois University started a medical school in Springfield. In 1988, Robert Morris College established a campus in Springfield. In 1995, Sangamon State University became a campus of the University of Illinois, and in 2003, Springfield College in Illinois joined in partnership with Benedictine University to offer bachelor's degrees.

The influx of multiple educational institutions changed the community in many ways. In combination with other factors, the advent of the higher education institutions created a new white-collar citizenry. Fresh ideas and contemporary aesthetics emerged. Public art no longer related only to Springfield's past. Rather, the new art reflected today and tomorrow. In support of this trend, Gov. James R. Thompson signed a law in 1977 that created the Art in Architecture (A-i-A) Program of the Capital Development Board. The schools took advantage of the program, and works by some of America's finest contemporary artists were erected on the campuses. The 20th-century art is symbolic of Springfield's emergence in the 1970s as a leader for the future.

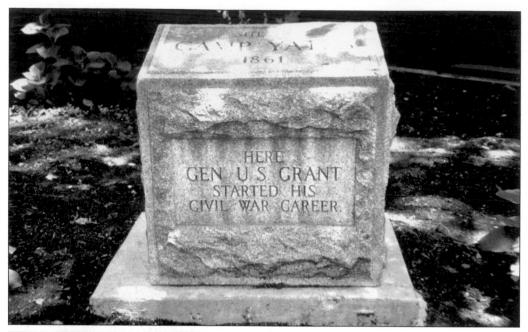

Ulysses S. Grant's first commission of the Civil War was commander of Camp Yates, a mustering and training camp for new recruits on the west side of Springfield. Although he spent only a few weeks at the camp in 1861, a marker was placed at the corner of Douglas Avenue and Governor Street in 1909 to commemorate the camp's significance. The elaborate granite stone complete with sundial and a large base deteriorated over the years, and in 1952 the DAR, the Chicago Civil War Round Table, and the Illinois State Historical Society obtained it. They determined it was beyond repair and replaced it with a marker that is now in the yard of Dubois School at 120 South Lincoln Avenue (above). What remains of the original 1909 monument still stands in the garden of the home at 345 South Douglas Avenue (left).

The plaque on a wall of McClernand Elementary School at 801 North Sixth Street notes that the home of the school's namesake, John A. McClernand, once stood on that site. McClernand served in the Illinois House of Representatives and the United States Congress. At the outbreak of the Civil War, he began a series of important commands in the Union Army. He returned to his law practice in 1864.

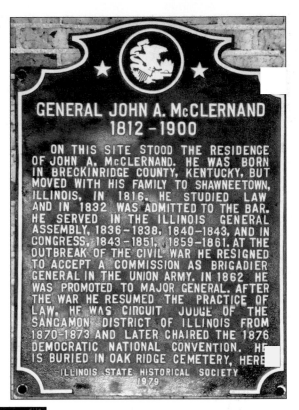

GENERAL JOHN A. McCLERNAND
1812–1900

ON THIS SITE STOOD THE RESIDENCE OF JOHN A. McCLERNAND. HE WAS BORN IN BRECKINRIDGE COUNTY, KENTUCKY, BUT MOVED WITH HIS FAMILY TO SHAWNEETOWN, ILLINOIS, IN 1816. HE STUDIED LAW AND IN 1832 WAS ADMITTED TO THE BAR. HE SERVED IN THE ILLINOIS GENERAL ASSEMBLY, 1836–1838, 1840–1843, AND IN CONGRESS, 1843–1851, 1859–1861. AT THE OUTBREAK OF THE CIVIL WAR HE RESIGNED TO ACCEPT A COMMISSION AS BRIGADIER GENERAL IN THE UNION ARMY. IN 1862 HE WAS PROMOTED TO MAJOR GENERAL. AFTER THE WAR HE RESUMED THE PRACTICE OF LAW. HE WAS CIRCUIT JUDGE OF THE SANGAMON DISTRICT OF ILLINOIS FROM 1870–1873 AND LATER CHAIRED THE 1876 DEMOCRATIC NATIONAL CONVENTION. HE IS BURIED IN OAK RIDGE CEMETERY, HERE
ILLINOIS STATE HISTORICAL SOCIETY
1979

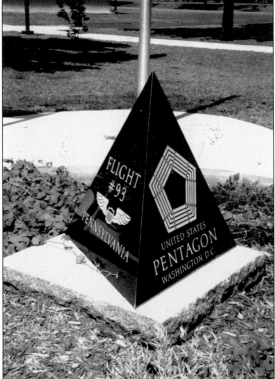

The design of the 9/11 memorial at the Capital Area Career Center campus on Toronto Road was created by three drafting students: Brandon Brown, Zach White, and Bethany Wright. Dedicated on September 10, 2004, the monument was executed by the Jacksonville Monument Company. Students in the agricultural mechanics and building trades classes created the setting for the pyramid. Retired instructor Dale Shanholtzer was the originator and primary underwriter of the project.

Two sculptures on the north side of Springfield are the result of the efforts of one dedicated art teacher, Marianne Stremsterfer. *St. Aloysius*, the statue outside the school on Sangamon Avenue named for the saint, is painted steel with cast bronze head and hands (left). Eighth-grade art students at St. Aloysius School not only raised money for the work but also assisted the artist, Jeff Garland, as he fabricated the piece. Stremsterfer, their teacher, spearheaded the project, which was dedicated on June 13, 1999. In 1994, as an instructor at Springfield College in Illinois, she led students in the design and construction of *Fountain of Dreams* (below) in front of the college administration building on North Fifth Street. The piece symbolizes students going on to fulfill all kinds of dreams from the base of what was then a junior college.

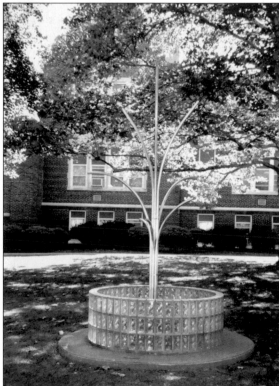

The plaque standing on North Eleventh Street in front of Lanphier High School commemorates the school's history, acknowledges north end industries, and honors Robert C. Lanphier, industrialist and community leader for whom the school was named. Lanphier High School stands on the site of what was once Reservoir Park. Opening in the 1870s, the park provided year-round recreational activities as well as an emergency water supply to Springfield. The commemorative plaque is sponsored by the school yearbook staffs of 1994 to 2007 and the Illinois State Historical Society. It was dedicated in April 2007. (Below, courtesy of Bill Furry.)

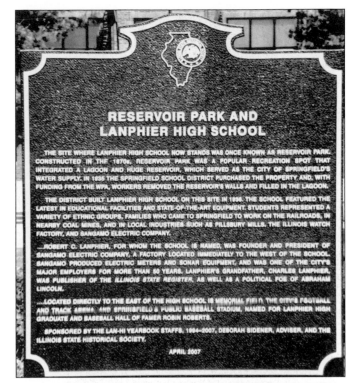

RESERVOIR PARK AND LANPHIER HIGH SCHOOL

THE SITE WHERE LANPHIER HIGH SCHOOL NOW STANDS WAS ONCE KNOWN AS RESERVOIR PARK. CONSTRUCTED IN THE 1870s, RESERVOIR PARK WAS A POPULAR RECREATION SPOT THAT INTEGRATED A LAGOON AND HUGE RESERVOIR, WHICH SERVED AS THE CITY OF SPRINGFIELD'S WATER SUPPLY. IN 1935 THE SPRINGFIELD SCHOOL DISTRICT PURCHASED THE PROPERTY AND, WITH FUNDING FROM THE WPA, WORKERS REMOVED THE RESERVOIR'S WALLS AND FILLED IN THE LAGOON.

THE DISTRICT BUILT LANPHIER HIGH SCHOOL ON THIS SITE IN 1936. THE SCHOOL FEATURED THE LATEST IN EDUCATIONAL FACILITIES AND STATE-OF-THE-ART EQUIPMENT. STUDENTS REPRESENTED A VARIETY OF ETHNIC GROUPS, FAMILIES WHO CAME TO SPRINGFIELD TO WORK ON THE RAILROADS, IN NEARBY COAL MINES, AND IN LOCAL INDUSTRIES SUCH AS PILLSBURY MILLS, THE ILLINOIS WATCH FACTORY, AND SANGAMO ELECTRIC COMPANY.

...ROBERT C. LANPHIER, FOR WHOM THE SCHOOL IS NAMED, WAS FOUNDER AND PRESIDENT OF SANGAMO ELECTRIC COMPANY, A FACTORY LOCATED IMMEDIATELY TO THE WEST OF THE SCHOOL. SANGAMO PRODUCED ELECTRIC METERS AND SONAR EQUIPMENT, AND WAS ONE OF THE CITY'S MAJOR EMPLOYERS FOR MORE THAN 50 YEARS. LANPHIER'S GRANDFATHER, CHARLES LANPHIER, WAS PUBLISHER OF THE *ILLINOIS STATE REGISTER*, AS WELL AS A POLITICAL FOE OF ABRAHAM LINCOLN.

...LOCATED DIRECTLY TO THE EAST OF THE HIGH SCHOOL IS MEMORIAL FIELD, THE CITY'S FOOTBALL AND TRACK ARENA, AND SPRINGFIELD'S PUBLIC BASEBALL STADIUM, NAMED FOR LANPHIER HIGH GRADUATE AND BASEBALL HALL OF FAMER ROBIN ROBERTS.

SPONSORED BY THE LAN-HI YEARBOOK STAFFS, 1994–2007, DEBORAH SIDENER, ADVISER, AND THE ILLINOIS STATE HISTORICAL SOCIETY.

APRIL 2007

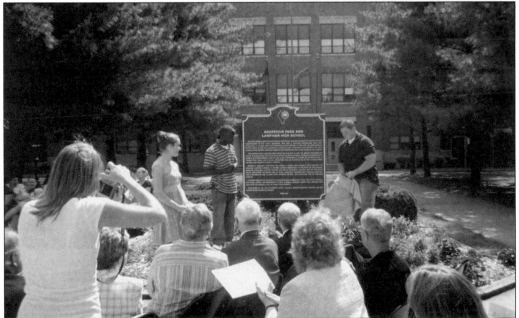

The plaque on the front lawn of Springfield High School identifies the site of Hutchinson Cemetery. From 1843, many early settlers including Abraham Lincoln's young son Eddie were interred there. In 1874, further burial in the cemetery was prohibited, and most bodies were removed to Oak Ridge Cemetery. The plaque is sponsored by the Springfield High School History Club and the Illinois State Historical Society. (Courtesy of Bill Furry.)

The Epicenter of Choice has stood on the Lewis Street lawn of Springfield High School since 1988. Led by artist Ken Burg and teacher Jim Edwards, students created the structure. The sculpture includes etched "graffiti" on the triangular panels, a seating area, and a time capsule underneath. The title refers to high school as the place where many choices are made in the transition from adolescence to adulthood.

The Southeast High School Spartan stands guard above the main entrance of the school on Ash Street. Originally used as a corporate symbol for Barker-Lubin, the fiberglass school mascot was donated by the Builder's Department Store in 1972. The school mascot was removed briefly in the early 1980s for school renovations and was beheaded by vandals in 1997. The Spartan resumed his position after an anonymous donor funded his repairs.

Guarding the entrance of Hazel Dell Elementary School on West Lake Drive is a steel wire mesh ostrich created in 1995 by artist Jeff Garland and art teacher Shirley Frankowiak. The sculpture was designed to be an interactive piece that the students could decorate or fill with recycled materials. The ostrich was selected to watch over the students because it is purported to be a fierce protector of its young.

The *Spaulding Fountain* in the courtyard of Brookens Library on the University of Illinois at Springfield campus was presented to the university by the family of Charles Herbert Spaulding on May 19, 1976. It commemorates Spaulding's research in the field of water purification. Ironically, because the fountain water leaked into the library causing structural damage, the sculpture has been a dry tribute to Spaulding since shortly after its installation.

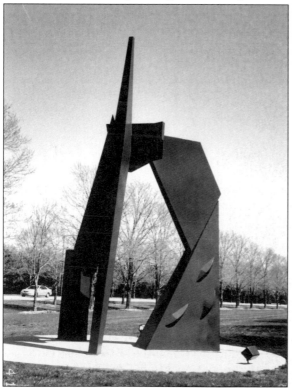

The 20-foot steel sculpture *Window's Edge* on the campus of the University of Illinois at Springfield was dedicated in 1991 in honor of George Hoffmann, a Springfield attorney who was instrumental in the founding of the institution. Artist Robert Dixon views the sculpture as a study of contrasts of shadows and light. He designed the work to complement and support the architecture of the surrounding campus.

In 1993, Chicago artist Thomas Skomski designed the 48-ton sculpture titled *Impermanent Column* for the campus of the University of Illinois at Springfield as an A-i-A commission. According to Skomski, the massive artwork is "a reminder of change. . . . Inherent in an institution of learning is the knowledge of change. The vitality of an institution is proportionate to its ability to work with change."

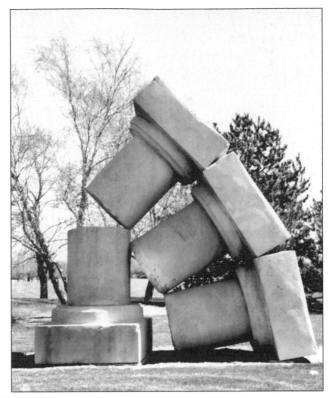

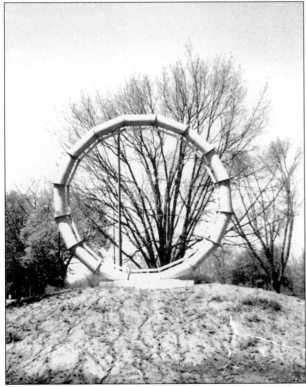

The A-i-A commissioned *La Terra* was dedicated on November 15, 2006, on the Lincoln Land Community College campus. Chicago artist Barry Tinsley said that the circular shape of his sculpture refers to Mother Earth. The combination of the granite from Coldspring, Minnesota, and man-made stainless steel is intended to be an environmental statement. It signifies how both the earth and mankind must complement each other.

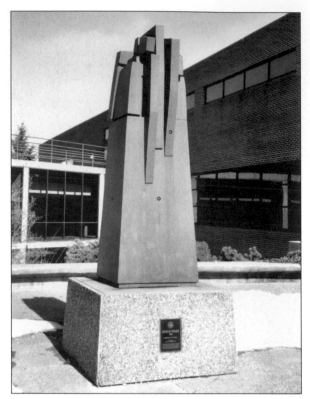

Stele Head was conceived by Michael A. Dunbar, a Springfield sculptor. Dr. Terry and Nancy Travis donated the artwork to Lincoln Land Community College in 1992. The inscription reads, "*Stele Head* is a guidepost, marking the pathway and serving to inspire those who pursue higher education at Lincoln Land Community College."

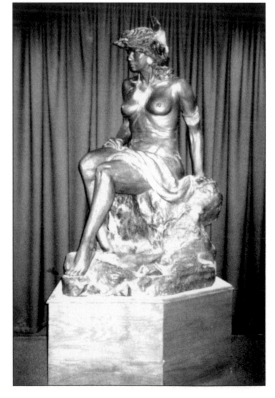

Desert Princess-Child of the Raven by Springfield native Marshall Mitchell (1917–2001) is on the second floor of Lincoln Land Community College's Menard Hall. In his long and prolific professional life, Mitchell achieved national acclaim as an "Old West" sculptor. Dedicated on May 9, 2002, the bronze princess was a gift to the Lincoln Land Community College Foundation by Mr. and Mrs. Glen Brandt and Mr. and Mrs. George R. Bunn.

There are seven sculptures by contemporary artists on the Southern Illinois School of Medicine campus sponsored by the A-i-A Program. Two artworks were installed in 1991. The imposing 12-foot glass and granite *Music for the Eyes* by William Carlson (right) stands near the corner of 911 Rutledge Street. Works by artist/educator Carlson are found in major museums throughout the world. His creations reflect his meticulous craftsmanship and his interest in geometry, texture, and color. By contrast, *Torre* by Chris Berti (below) stands just 78 inches tall beneath a bridge between buildings. This limestone sculpture exemplifies Berti's ability to recreate animals and everyday objects with honesty and care. A ceramic artist by training, Berti taught himself to work in stone, following in the path of his stonemason grandfather.

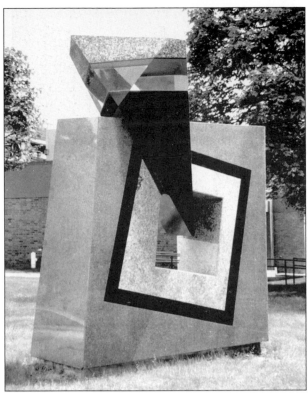

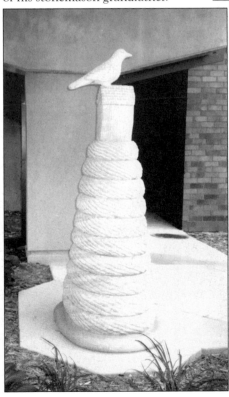

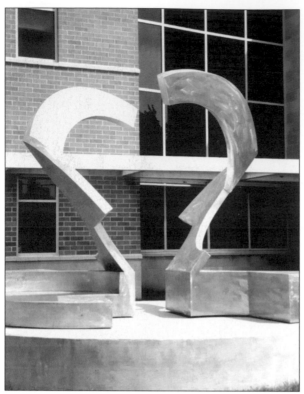

Two Chicago artists with Illinois State University (ISU) associations produced A-i-A commissions that were installed at Southern Illinois University Medical School in 2005. Ed McCullough, creator of *Enigma Variation II* (left), is a graduate of ISU, and Barry Tinsley, designer of *Beacon* (below), has been an instructor there. The eight-foot, stainless steel McCullough piece is in front of 327 West Calhoun Avenue. Other pieces by the artist can be seen at the Chicago Police Headquarters building, the Central Illinois Regional Airport in Bloomington, and the Federal Reserve Bank of Chicago. Tinsley's 13-foot granite and steel structure is found on the west side of 801 North Rutledge Street. Now a full-time sculptor, Tinsley has created 35 large-scale sculptures in private, corporate, and municipal locations throughout the United States and Europe.

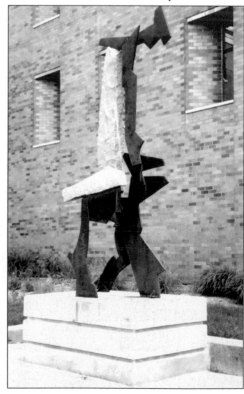

Works by two Chicago artists were commissioned by the A-i-A Program for the Southern Illinois School of Medicine campus in 2005. *Night Veils* (right) by Jerry Peart is found on the north side of 825 North Rutledge Street, and *Free Song* (below) by Mike Helbing is on the southeast corner of Hay and Reisch Streets. Peart specializes in site specific large-scale abstract works. Over 20 of his large pieces are found in public spaces throughout the United States. His Springfield sculpture is a 10-foot blue aluminum structure. Like many of his works, Helbing's 13-foot stainless steel sculpture implies motion. He finds inspiration in the shapes of trees and the movements of dancers. Other works by Helbing can be found in the National Vietnam Veterans Museum in Chicago where he serves as curator.

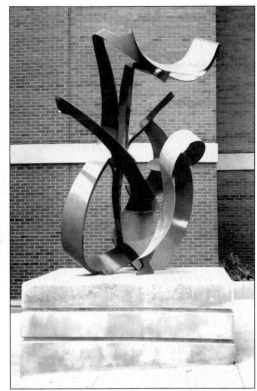

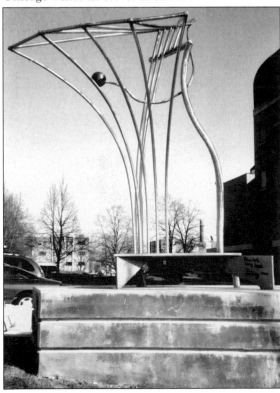

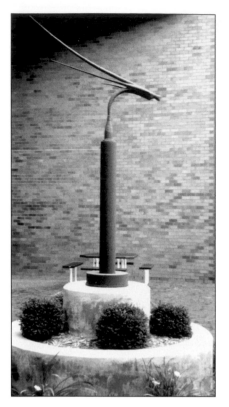

Two statues stand in the courtyard of 801 North Rutledge Street. A-i-A commissioned *Icarus* (left), a forged steel structure by L. Brent Kington installed in 2005, is in the northwest corner. A trained silversmith, Kington discovered blacksmithing in 1964. Subsequently, he developed a model metalsmithing program at Southern Illinois University at Carbondale where he taught and has become a national leader in blacksmithing as a contemporary art form. *Harbinger of Good Will* (below) by Kenneth Ryden stands in the courtyard's southeast corner. It was commissioned by the Southern Illinois University Foundation in 1981 to commemorate the Medical School's 10th anniversary. According to Ryden, the work, "represent[s] the many aspects of medicine. . . . The wings are suggestive of medical practice, offering dignity, hope and good will, and the figure itself symbolizes the spiritual essence of humanity."

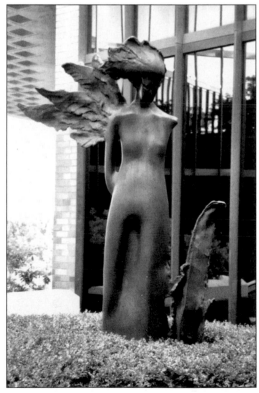

Five

WHERE THE PAST RESTS
OAK RIDGE CEMETERY

In June, 1855, Springfield City Council member Charles H. Lanphier persuaded the city to purchase land outside the city for a new burial ground. Health concerns and the need for more space prompted the city council to purchase 28.5 acres north of the city and to prohibit any further burials within the city limits. The name Oak Ridge, suggested by Mayor John C. Cook, is derived from the large stand of oak trees that stood on the land. Many of those trees remain on the property. Oak Ridge Cemetery was dedicated on May 24, 1860. Abraham and Mary Lincoln were likely among the attendees. When President Lincoln died five years later, Mary insisted that he be buried in Oak Ridge.

The cemetery today includes more than 300 acres with 12 miles of winding roads. Six of those acres are dedicated to the Lincoln Tomb State Historic Site. In addition to Abraham Lincoln's tomb, the cemetery contains monuments to Illinois veterans of the Civil War, World War II, and the Vietnam and Korean Wars. While Arlington National Cemetery is the most popular cemetery for visitors in the United States, Oak Ridge Cemetery is the second most visited. Entrance to the cemetery is reached from the intersection of North Grand Avenue and Monument Boulevard or from Walnut Street.

The selected images from Oak Ridge Cemetery are significant because of the stories they tell. The gravestones and monuments reveal history through the lives of Springfield society from Lincoln's contemporaries to today's citizens. They also remind people of the ironies of life and death. While ordinary people rest under extraordinary monuments, men and women of enormous power in life are remembered with simple stones. Orphaned, nameless children lie near the city's wealthy merchants. Through its monuments, sculptures, and plaques, Oak Ridge Cemetery reflects historic and contemporary Springfield more than any other place in the community.

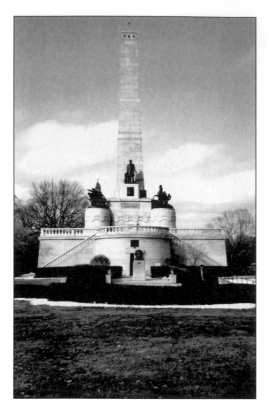

Vermont sculptor Larkin G. Mead designed the magnificent monument and six of the seven sculptures on the exterior of the final resting place of Abraham Lincoln (left). Groups of bronze military statuary are seen at the four corners of the structure: infantry on the southwest, cavalry on the southeast, naval on the northeast, and artillery on the northwest. A bronze statue of Lincoln called *The Emancipator* stands on the southern side of the central obelisk (below). He holds a pen in his right hand and the Emancipation Proclamation in the other. Beneath his feet in bas-relief is a modified coat of arms of the United States. Ground was broken for the monument on September 9, 1869, and the capstone on top of the central obelisk was installed on May 22, 1871. The Lincoln statue was not put into place until 1874.

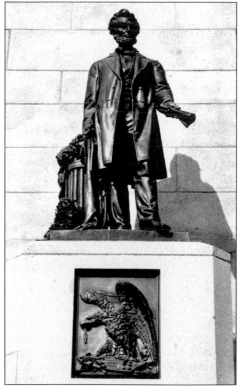

The bust of Lincoln in front of his tomb was designed by Gutzon Borglum, the Mount Rushmore sculptor. The *Lincoln Head* is the only replica artwork on the exterior of the monument. The original is in the Capitol Crypt in the United States Capitol building. The nose of Borglum's Lincoln in Oak Ridge has been stroked for good luck by thousands of visitors since its installation.

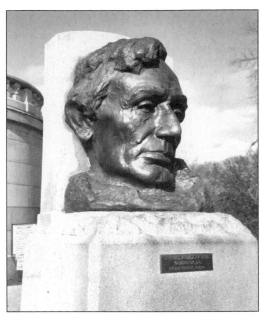

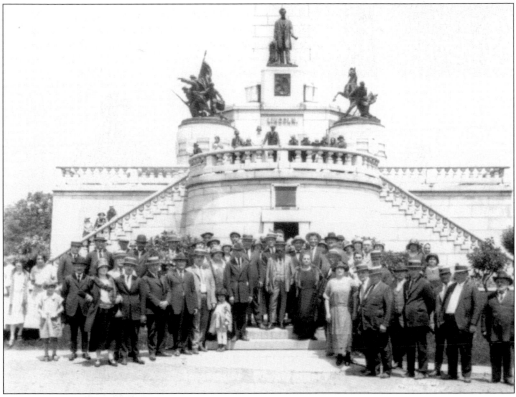

Lincoln's tomb is a requisite stop for celebrity visitors. Joseph Rosenblatt, nationally renowned cantor, posed with members of the Jewish community during his visit to the tomb in the 1920s. Rosenblatt was the cantor in a large synagogue in New York City. Surviving recordings support his reputation as a phenomenal singer. It is surmised that Rosenblatt was in Springfield to present a concert. (Courtesy of Sangamon Valley Collection, Lincoln Library.)

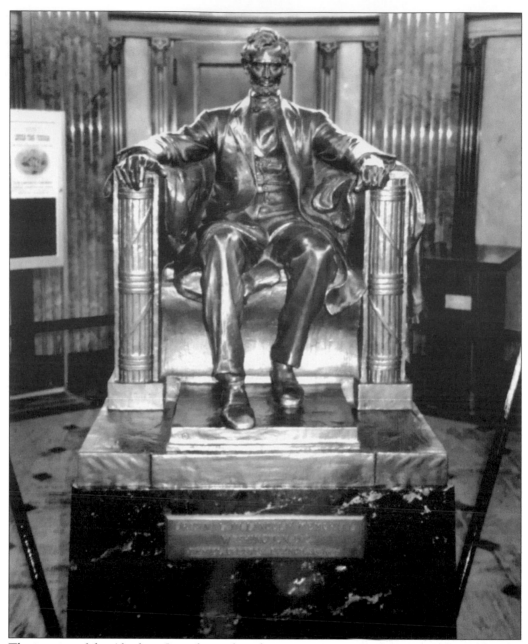

The interior of the Abraham Lincoln tomb underwent a major reconstruction in the 1930s. The original sandstone was replaced with marble hallways and floors, and a red marble memorial stone was added. Four bronze plaques relating to Lincoln were affixed to the walls, and three bronze tablets describing the construction and remodeling of the tomb were embedded in the floor. Additionally, nine bronze statuettes depicting various stages of Lincoln's life were added. Seven of the nine are replicas of Lincoln statues found throughout the Midwest. Among the replicas is a small version of the famous *Seated Lincoln* by Daniel Chester French who was sometimes called the sculptor of memorials. This is an image of Lincoln as the Civil War president with the Roman fasces, symbols of power, serving as arms for the chair in which he sits. The original *Seated Lincoln* is in the Lincoln Memorial in Washington, D.C.

Sculptor Fred M. Torrey created the two original equestrian statues found inside the Lincoln tomb. *Lincoln the Ranger* (right), sometimes referred to as "The Scout," recalls Lincoln's service in 1832 as a member of the Illinois militia during the Black Hawk War. *Lincoln the Circuit Rider* (below) commemorates Lincoln's life on the judicial circuit, which required lawyers to travel from one county courthouse to another. Torrey specialized in statues depicting Lincoln in informal poses wearing something other than the usual frock coat and top hat. Other famous works by the artist are *At Twenty-One I Came to Illinois* on the Millikin University campus in Decatur, Illinois, and *Abraham Lincoln Walks at Midnight* on the grounds of the West Virginia State Capitol.

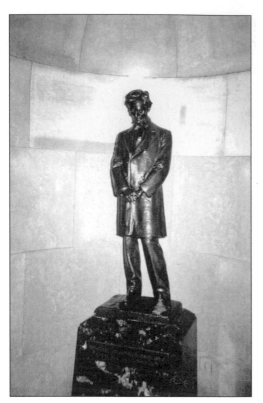

One of the two replicas of statues by Daniel Chester French in the Abraham Lincoln tomb is the artist's interpretation of Lincoln minutes before he gave his Gettysburg Address. The original, dedicated in 1912, stands near the west entrance of the Nebraska State Capitol building in Lincoln, Nebraska. In back of the original bronze is a 20-by-12-foot marble slab with the Gettysburg Address inscribed.

The larger-than-life original bronze of a seated President Lincoln by Adolph Weinman was erected in Lincoln's birthplace, Hodgenville, Kentucky, in 1909, the centennial of his birth. Like the original, the replica in the tomb depicts a thoughtful Lincoln. Although Weinman created many figure sculptures in his long career, he is most remembered for his architectural sculptures and designs of the mercury dime and the liberty half dollar in 1916.

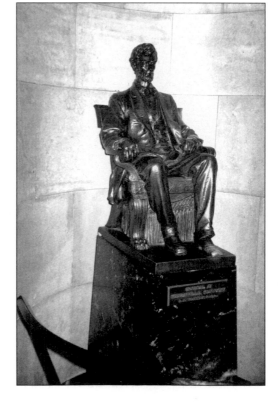

Two replicas of statues of young Lincoln by major sculptor Leonard Crunelle stand in the tomb. Born in France, Crunelle immigrated to nearby Decatur, where he worked in the coal mines and carved figures from coal in his spare time. Famed sculptor and teacher Lorado Taft discovered Crunelle and mentored him at the Art Institute of Chicago. *Lincoln the Soldier* (right) captures Lincoln at age 23 when he served in the Illinois Militia. The original is in Dixon on the site of the old Dixon blockhouse on the Rock River. The original *Lincoln the Debater* (below) is in Taylor Park in Freeport, where the second of the seven Lincoln-Douglas debates was held on August 27, 1858. In bronze, Crunelle portrays a self-confident young Abraham Lincoln challenging the elder Stephen A. Douglas, the foremost debater of the day.

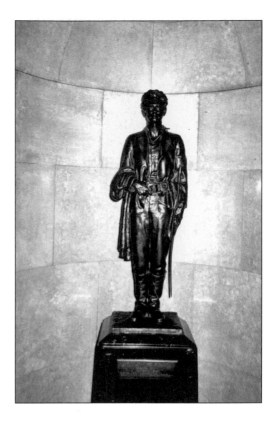

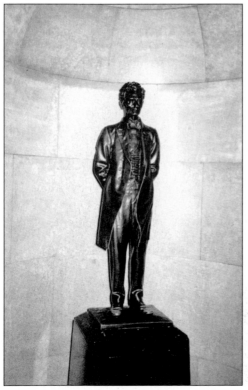

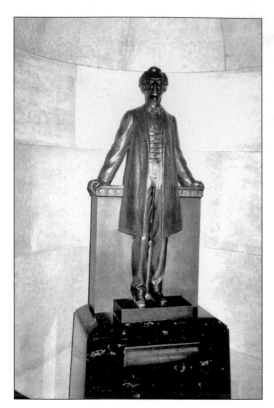

The original *Lincoln the Lawyer* by legendary Illinois sculptor Lorado Taft stands in Carle Park in Urbana. Like the original, the tomb replica depicts Abraham Lincoln with his hands resting on a stone slab. Two Lincoln quotations are carved on the slab. One is from the Peoria speech in 1854, and the other is from the president's opinion in 1863 on the admission of West Virginia to the Union.

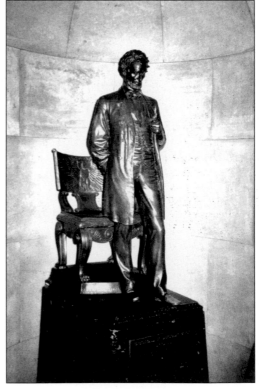

Augustus Saint-Gaudens spent several years conceptualizing the original *Standing Lincoln*, which is in Lincoln Park in Chicago. Saint-Gaudens, considered the foremost sculptor of his day, was the first to use Lincoln's life mask for this piece. Visitors to the tomb see in the replica the face of a president troubled by war standing in front of the chair of state. The original was unveiled on October 22, 1887.

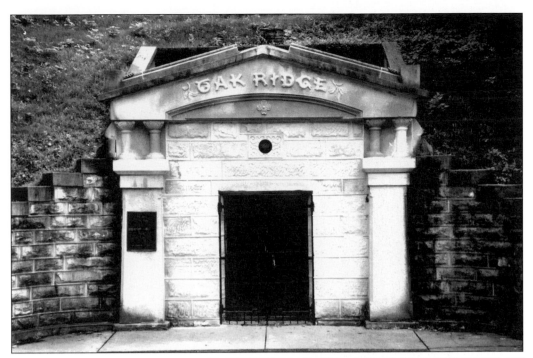

When Lincoln died on April 15, 1865, Mary Lincoln insisted that he be buried in Oak Ridge Cemetery. After a service in the White House on April 19, Lincoln's body lay in state in the nation's Capitol rotunda. On April 21, a 13-day train journey took the fallen president past bereaved mourners to Springfield. On May 3, Lincoln arrived home where his body lay in state in what is today the Old State Capitol. On May 4, the funeral procession moved to Oak Ridge Cemetery. The bodies of Abraham and his son Willie remained in the receiving tomb (above) until December 21 when they were transferred to a specially built temporary tomb. The receiving tomb was available for those who in "sudden bereavement" had not chosen a lot. The fee for using the tomb was $5. Victims of smallpox or cholera were forbidden.

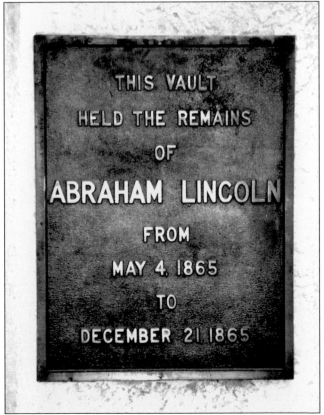

THIS VAULT HELD THE REMAINS OF ABRAHAM LINCOLN FROM MAY 4, 1865 TO DECEMBER 21, 1865

In addition to his appointment as governor of the Illinois Territory (1809–1818) and his election as governor of the state (1826–1830), Ninian Edwards held many judicial posts. His long career in public service ended when he died during a cholera epidemic in Belleville. Edwards was originally interred in Belleville, but his sons later brought him to Springfield where they lived.

Elected in 1856, William H. Bissell was the first Republican governor of Illinois. Trained as both a physician and a lawyer, he also represented Illinois in the U.S. Congress (1849–1855), where he reportedly was challenged to a duel by Jefferson Davis. Friends interceded, and Bissell died in office in 1860.

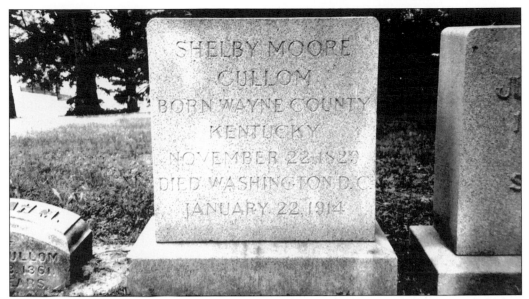

Shelby Moore Cullom was elected to his first public office in 1855, that of Springfield city attorney. For the next 58 years, the man known as "Mr. Republican" of Sangamon County held almost every elective office including two terms in the Illinois House of Representatives, three terms in the U.S. House of Representatives, one-and-a-half terms as governor, and five terms in the U.S. Senate. Cullom died in Washington, D.C.

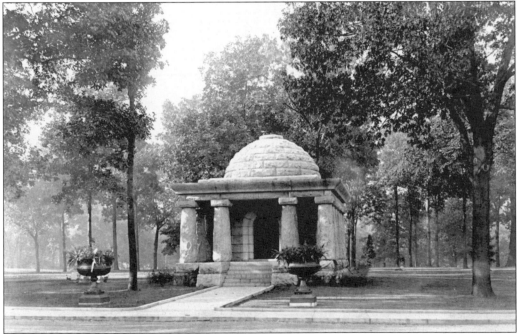

A master of political strategy, John Riley Tanner was elected the 21st Illinois governor in 1896. Unsuccessful in his 1900 challenge for the senate seat of his mentor, Shelby Moore Cullom, Tanner left the governor's office politically and physically broken. He died four months later. His love of pageantry is reflected in his grand mausoleum near the cemetery entrance erected by friends and admirers. (Courtesy of Sangamon Valley Collection, Lincoln Library.)

Abraham Lincoln's three law partners rest with him in Oak Ridge Cemetery. His first partner was John Todd Stuart (left). Stuart and Henry Dummer, his first partner, initiated a law firm that has evolved into today's Brown, Hay and Stephens, the oldest law practice in Illinois. The young Lincoln received valuable experience through this partnership because he handled much of the firm business as Stuart campaigned for and served in the U.S. Congress. Lincoln reversed roles with his third partner, William "Billy" Herndon (below). While Lincoln rode the circuit and served in the U.S. House of Representatives, Herndon managed the office and oversaw the cases. Herndon's biography of Lincoln, *Herndon's Lincoln: The True Story of a Great Life* has remained an important source for Lincoln scholars since its publication in 1889.

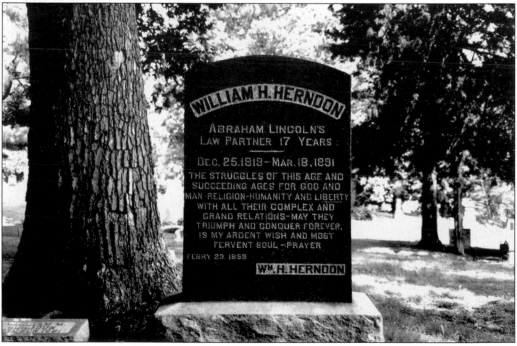

In addition to a successful law career, Lincoln's second partner, Stephen T. Logan (right), pursued a very active political career. He served several terms in the Illinois General Assembly and was elected to the Illinois Constitutional Convention in 1847. Logan attended the 1860 Republican National Convention that nominated Lincoln for president and presided over the Illinois Republican Convention of 1872 that nominated Ulysses S. Grant for the same office. By contrast, Milton Hay (below) was not involved in politics. However, he maintained a close relationship with Lincoln and other contemporary luminaries. Logan was Hay's father-in-law. Hay studied law in the firm of Stuart and Lincoln. Hay and Lincoln worked together on approximately 17 cases. Later he was the law partner of two future governors: Shelby Moore Cullom and John M. Palmer. Both Logan and Hay died in their Springfield homes.

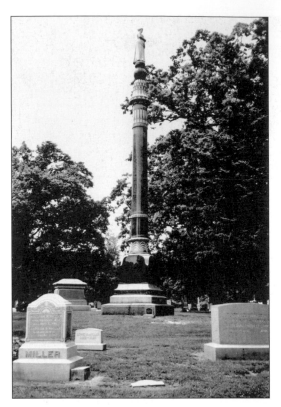

A white marble Mattie S. Rayburn stands at the top of the imposing 40-foot polished Scotch granite shaft, second in height in the cemetery only to Lincoln's tomb. Married to a charismatic itinerant pastor, Mattie's biography is sketchy and tinged with scandal. Ironically, the inscription at the base reads, "What therefore God has joined together let not man put asunder." Bishop Rayburn is buried somewhere in Europe.

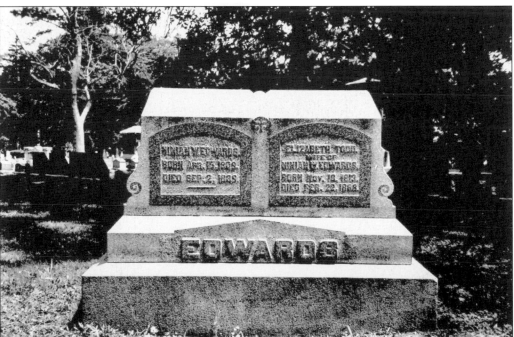

Ninian W. Edwards was the son of the territorial governor of Illinois, Ninian Edwards. His wife, Elizabeth, was Mary Todd Lincoln's sister. Ninian W. served as attorney general and in the Illinois legislature. Abraham Lincoln and Mary Todd met and were married in the Edwards' home.

A close friend of Lincoln, Edward Lewis Baker was editor and co-owner of the *Illinois State Journal*. His wife Julia was the daughter of Ninian W. and Elizabeth Edwards. In 1873, he was appointed U.S. consul at Buenos Aires, Argentina, where he died as the result of an accident. Baker's monument in the Edwards' family plot with a bas-relief portrait of him was erected by Argentine friends.

A German immigrant, John M. Burkhardt was a dry goods merchant and tavern operator. As an active member of the German community in Illinois, he owned a German-language newspaper. Lincoln purchased the printing press and the types for the German language from Burkhardt, a Democrat, in 1860 to publish the Republican platform in German. Burkhardt died of dropsy in Springfield.

In addition to building Springfield's first store and largest hotel, Elijah Iles, a Kentucky migrant, was a land speculator, farmer, and soldier. Even Abraham Lincoln bought property from Iles. During his lifetime he amassed considerable wealth, which he shared in numerous philanthropic endeavors. When his wife of 42 years died in 1866, he retired from business and wintered in Florida. He died at the age of 87.

Norman Broadwell moved to Springfield in 1850 at the age of 25 and began studying law with Lincoln and his partner William Herndon. Broadwell served as mayor of Springfield, an Illinois legislator, and judge of the Sangamon County Court. He and his wife Nancy, daughter of Elijah Iles, lived in a house near the present site of the Illinois Executive Mansion, where he died on February 18, 1893.

James Cook Conkling was a Princeton University graduate. He moved to Springfield in 1838 where he practiced law. He also served as mayor and in the Illinois House of Representatives. Conkling delivered the main address at the Oak Ridge Cemetery dedication. His wife, Mercy, was a close friend of Mary Todd Lincoln.

A tall monument honors Alfred Piquenard, the French immigrant who was responsible for the design and construction of the present Illinois State Capitol building. He also designed the Iowa State Capitol building and several other surviving structures throughout the Midwest. In 1870, Piquenard moved to Springfield to oversee the construction. He died in his Springfield home in 1876 and was buried in Oak Ridge Cemetery beside his young daughter.

Two Springfield businessmen who played significant roles in Abraham Lincoln's life are neighbors in Oak Ridge Cemetery as they were neighbors on Springfield's Aristocracy Hill. George Chatterton Sr. (left) was a successful jeweler from whom young Lincoln purchased the Etruscan gold wedding band that he gave to his bride. Chatterton established an opera house, which became Springfield's most famous theater of the time. He died in his elegant Springfield home on March 27, 1888. Jacob Bunn (below) founded a wholesale grocery business, a bank, and the Springfield Watch Company. He advised the Lincoln family on financial matters, contributed generously to Lincoln's candidacy, and loaned money to the state to support the volunteers in the Civil War. Additionally, Bunn was a leader in numerous civic and philanthropic activities. He died in his Springfield Watch Company office on October 16, 1897.

Edward Levanius was a talented and popular stonecutter from this area. Hundreds of stones carved by him are in Oak Ridge Cemetery. Levanius's monuments are replete with symbols of the deceased's life. For example, Thomas Strawbridge Jr. (right), a saddler by trade, was one of the first skilled craftsmen in Sangamon County. He and his sister Mary rest beneath a Levanius monument. The Strawbridge memorial includes a chair with Thomas's hat and one with Mary's cloak. Levanius chose to depict the face of Erastus Wright (below), an early schoolteacher who became school commissioner in Sangamon County. His bust with a stern face at the top of his monument suggested that he oversaw a no-nonsense classroom. Unfortunately, vandals have removed the bust, but the monument remains an example of the craftsmanship of Levanius.

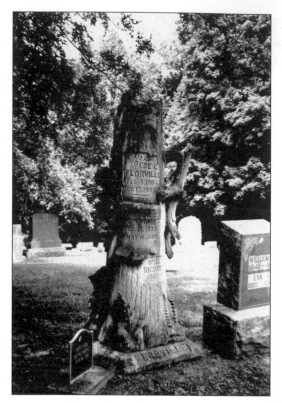

Phoebe C. Florville is buried with two of her five children beneath a symbolic monument. The memorial is a carved tree with broken limbs that symbolize a life cut short. Phoebe was the daughter of Lucy Rountree, a member of the oldest African American family in Sangamon County. Her first husband William, buried in Calvary Cemetery, was Abraham Lincoln's barber and friend. After his death, she married Reuben Coleman.

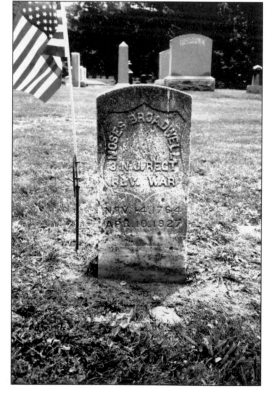

Moses Broadwell is the only Revolutionary War soldier buried in Oak Ridge Cemetery. Broadwell, his wife, and 12 children traveled from New Jersey to Pleasant Plains in 1820 where they built the first brick home in Sangamon County. Broadwell was first buried in 1827 in Pleasant Plains Cemetery, but he was reinterred at Oak Ridge in 1862. A small government stone marks his grave.

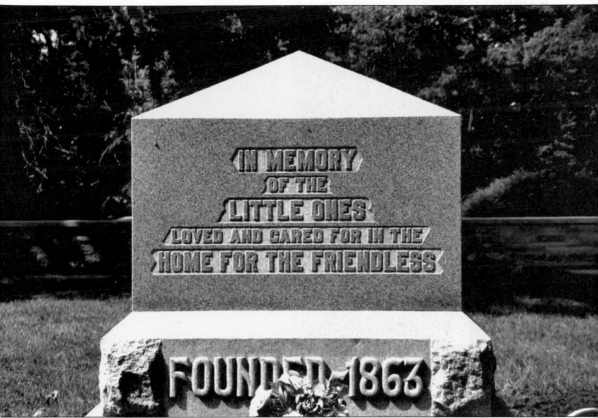

Victims of the Civil War, many impoverished widows and orphans from the southern border states sought refuge in Springfield. To accommodate them, several leading citizens spearheaded the founding of the Home for the Friendless, created by a legislative act in 1863. Springfield residents donated money to build the home. The first group of refugees was brought to Springfield by Francis Springer from Fort Smith, Arkansas, in January 1865. The home served over 1,000 needy and orphaned children until it closed in 1904. The building was razed in 1935, but the Family Service Center, a social service agency, stands on the property today, still meeting the needs of Springfield families. A simple marker in Oak Ridge Cemetery identifies the site where the children were buried. Recent research indicates that only 52 children are interred in the area rather than the hundreds that historians had assumed. The Home for the Friendless Memorial Renovation Project is planning to build a limestone wall behind the existing marker to memorialize the children appropriately.

In 1948, Sangamo Electric Company erected a memorial in Oak Ridge Cemetery to their employees who fought in the two world wars but did not return. Founded in 1899 to produce electric meters, Sangamo Electric Company was a major manufacturer in Springfield. By developing new technology to meet new needs, the company thrived for many years. It employed 2,700 people in 1947, but the company was closed in 1977.

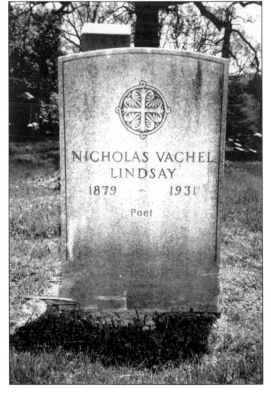

Springfield native Vachel Lindsay was a poet/troubadour whose poems such as "General William Booth Enters Heaven" and "Abraham Lincoln Walks at Midnight" received national acclaim. The poet had a love/hate relationship with his hometown. He wrote: "In this, the City of my Discontent, sometimes there comes a whisper from the grass, 'Romance, romance—is here.'" Lindsay committed suicide in the home in which he was born.

A graduate of Old Central High School (predecessor of Springfield High School), Susan Wilcox became a legendary English teacher at Springfield High School. Among her students was Vachel Lindsay who credited Wilcox as an inspiration to him. A Springfield elementary school is named to honor Wilcox.

Elizabeth Graham was an inspiring English teacher at Springfield High School. After her retirement, she devoted all of her time and much of her own resources to perpetuate the memory of Vachel Lindsay. Graham was a cofounder of the Vachel Lindsay Association and for 21 years tended his family home. The home is currently administered by the Illinois Historic Preservation Agency.

Born on Abraham Lincoln's birthday, February 12, 1880, John Llewellyn Lewis started his career as a labor leader in nearby Panama, Illinois, where he was secretary of the local miner's union. Lewis went on to national prominence as president of the United Mine Workers (UMW) and founder of the Congress of Industrial Organizations (CIO). Lewis did more than anyone else to organize the nation's workers into unions, but not without cost. He returned to Springfield in 1932 to mediate contentious contract negotiations. Through the negotiation process, a dissenting group broke from the UMW to form the Progressive Mine Workers of America (PMWA). Violence ensued. On September 25, 1932, miners rioted in downtown Springfield, and a police officer was killed. Lewis died in 1969 in his home in Alexandria, Virginia, and was buried in the Lewis family plot in Oak Ridge Cemetery beneath a simple headstone (below).

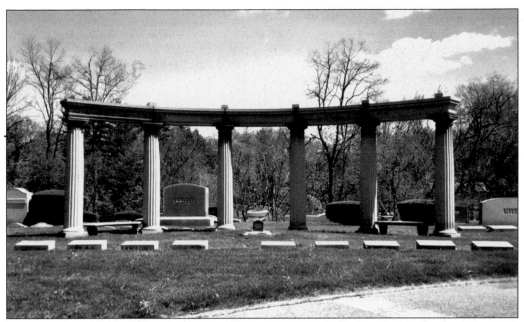

This monument honors Thomas Rees, publisher of Springfield's *Illinois State Register* from 1881 to 1933. He served as a senator in the Illinois General Assembly and authored a series of travel books. Through his travels to Belgium and Holland, Rees became interested in carillons and established a trust fund to build one in Springfield. The Thomas Rees Memorial Carillon in Washington Park is the result of his passion and generosity.

Roy Bertelli was a lifelong resident of Springfield who was a performer, composer, arranger, and teacher of the accordion. When he died in 2003 at the age of 92, he was buried in the mausoleum he designed and dedicated to the accordion. A showman to the end, Bertelli rests at the entrance of Oak Ridge Cemetery.

Two areas in Oak Ridge Cemetery are set aside for veterans of the Union Army. One plot is marked by a 14-foot Italian marble monument erected in 1874 (left). The names of 40 Union soldiers are inscribed on the monument. Thirteen of those soldiers are buried around the monument, and the remaining 27 are buried in family plots throughout the cemetery. The other Union burial area is the GAR mound (below). The GAR was a Union veteran's organization founded in Springfield in 1866. It grew to more than 400,000 members nationally by the 1890s. The Oak Ridge Cemetery board of managers donated a plot of ground to the Springfield GAR post in 1891 for burial of Union veterans who did not have family plots elsewhere. Approximately 97 soldiers are buried there.

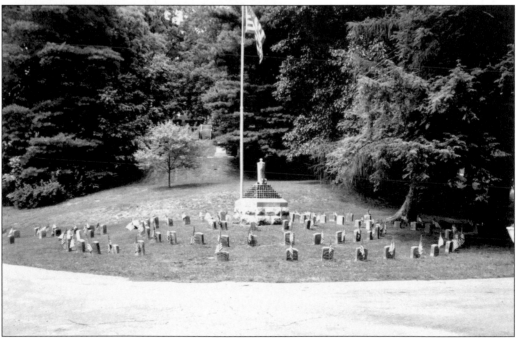

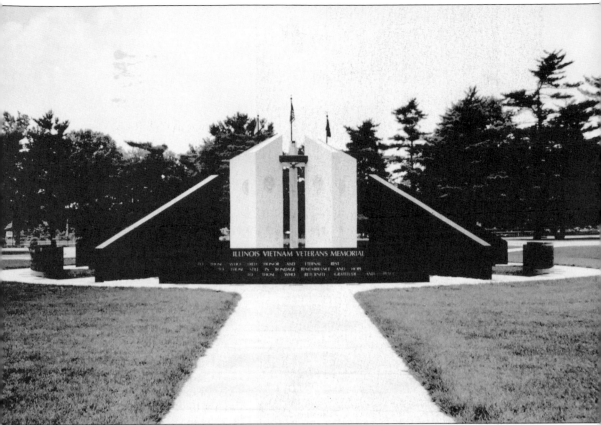

Three impressive memorials to Illinois military personnel stand near the Walnut Street entrance of Oak Ridge Cemetery. All were created within a 16-year timespan through private fund-raising efforts and donated time. Each is a unique design. The first to be erected was the Illinois Vietnam Veterans Memorial, which was dedicated on May 7, 1988. Five gray granite walls with almost 3,000 names of Illinoisans who died in the Vietnam War or are still missing surround an eternal flame on top of the memorial. Each of the five walls of the monument bears the insignia of one of the service branches. The designer was Jerome Lager of Breese, and the project architect was Vietnam veteran Gary Likins of Decatur. The inscription on the outer wall summarizes the intent of all three memorials: "To those who died honor and eternal rest, to those still in bondage remembrance and hope, and to those who returned gratitude and peace."

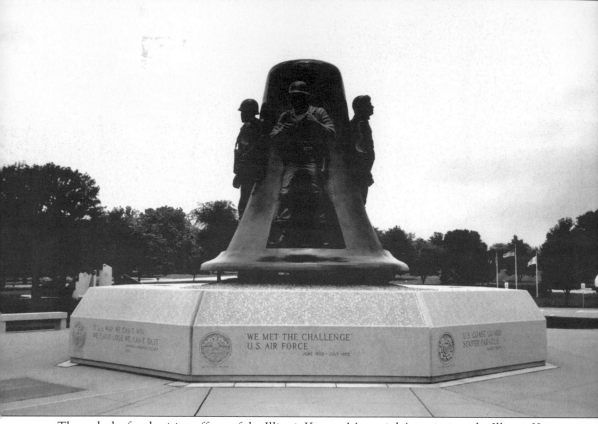

Through the fund-raising efforts of the Illinois Korean Memorial Association, the Illinois Korean War Memorial was dedicated on June 16, 1996. Designed by Robert Youngman, sculptor and professor at the University of Illinois at Urbana-Champaign, and cast by the Johnson Atelier Foundry in Mercerville, New Jersey, the monument has a centerpiece of a 12-foot bronze bell. The bell is surrounded by four uniformed servicemen, each representing a branch of the military. Musical selections are played every half hour from a sound system installed within the memorial, and spot lights illuminate it at night. Four hundred rose of Sharon trees donated by the people of Korea surround the memorial. The names of 1,745 Illinoisans killed in Korea are inscribed along eight walls of the memorial's granite base. Below the names are quotations from representatives of each branch of the armed forces.

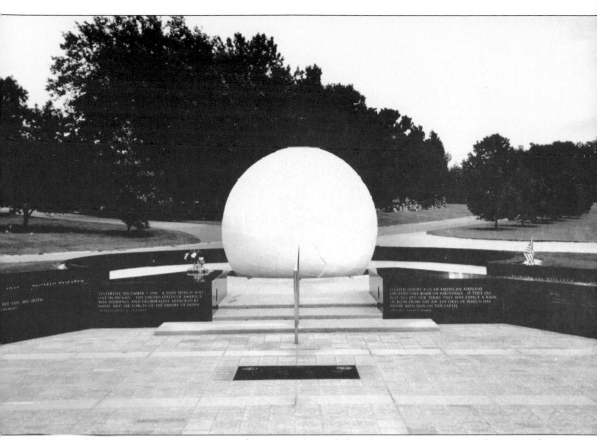

The World War II Veterans Memorial was the last of the three monuments to be erected. Dedicated on December 4, 2004, the memorial is a tribute to the nearly 987,000 Illinois men and women who served and the more than 22,000 who died in that war. Jeff Poss of Urbana, in collaboration with Isaksen-Glerum Architects, designed the memorial, and Dann Nardi of Normal sculpted the 12-foot diameter concrete globe, a symbol of the worldwide implications of World War II. The globe is embedded with stainless steel buttons each of which indicates an important battle in either the European or Pacific theaters of the war. Each button has a number that corresponds to the name of the battle location engraved on the granite walls that extend from the center globe. Bricks with names of Illinois veterans form walkways along the granite walls and the surrounding plaza.

BIBLIOGRAPHY

Angle, Paul M. *"Here I Have Lived": A History of Lincoln's Springfield, 1821–1865.* Springfield, IL: Abraham Lincoln Association, 1935.

———. *One Hundred Fifty Years of Law: An Account of the Law Office Which John T. Stuart Founded In Springfield a Century and a Half Ago.* Springfield, IL: Brown, Hay and Stephens, 1978.

Art Collection for the Willard Ice Building Purchased through the State of Illinois Art-in-Architecture Program of the Capital Development Board. Springfield, IL: State of Illinois, 1994.

Barringer, Floyd S. *Tour of Historic Springfield.* Springfield, IL: Self-published, 1971.

Barringer, Floyd S., and Richard L. Kahne. *A Walk through Oak Ridge Cemetery.* Springfield, IL: Sangamon County Historical Society, 1967.

Campbell, Bruce. *The Sangamon Saga.* Springfield, IL: Phillips Brothers, Inc., 1976.

Hart, Richard E. *Lincoln's Springfield: The Public Square (1823–1865).* Springfield, IL: Elijah Iles House Foundation, 2004.

Howard, Robert P. *Mostly Good and Competent Men.* 2nd ed. Springfield, IL: University of Illinois at Springfield, 1999.

———. *A New Eden: The Pioneer Era in Sangamon County.* Springfield, IL: Sangamon County Historical Society, 1974.

Krause, Susan, Kelley A. Boston, and Daniel W. Stowell. *Now They Belong to the Ages: Abraham Lincoln and His Contemporaries in Oak Ridge Cemetery.* Springfield, IL: Illinois Historic Preservation Agency, 2005.

O'Brien, Francis J. *The Fabulous Franklin Story: The History of the Franklin Life Insurance Company, 1884–1970.* Springfield, IL: Franklin Life Insurance Company, 1972.

Russo, Edward J. *Prairie of Promise: Springfield and Sangamon County.* Woodland Hills, CA: Windsor Publications, 1983.

Sorensen, Mark W., ed. *Capitol Centennial Papers: Papers Prepared for the Centennial Observation of the Completion of the Illinois State Capitol.* Springfield, IL: Illinois State Archives, 1988.

Winkle, Kenneth J. *The Young Eagle: The Rise of Abraham Lincoln.* Dallas, TX: Taylor Trade Publishing, 2001.

INDEX

ACROSS AMERICA, PEOPLE ARE DISCOVERING SOMETHING WONDERFUL. *THEIR HERITAGE.*

Arcadia Publishing is the leading local history publisher in the United States. With more than 3,000 titles in print and hundreds of new titles released every year, Arcadia has extensive specialized experience chronicling the history of communities and celebrating America's hidden stories, bringing to life the people, places, and events from the past. To discover the history of other communities across the nation, please visit:

www.arcadiapublishing.com

Customized search tools allow you to find regional history books about the town where you grew up, the cities where your friends and family live, the town where your parents met, or even that retirement spot you've been dreaming about.